IMAGES
of America

PORTAGE TOWNSHIP

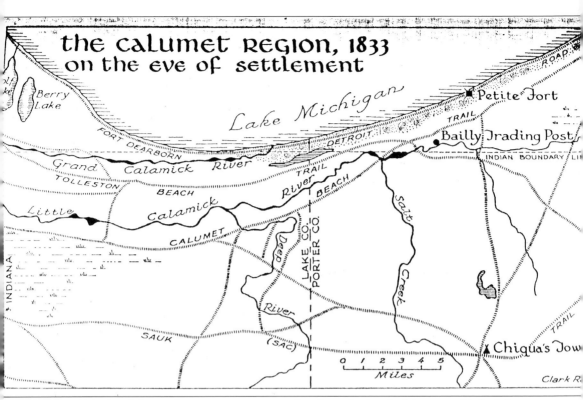

the calumet Region, 1833
on the eve of settlement

Berry Lake

Lake Michigan

Petite Fort

FORT DEARBORN

DETROIT

TRAIL

Bailly Trading Post

Grand Calumick River

TOLLESTON BEACH

INDIAN BOUNDARY LINE

Little

Calumick

River

BEACH

CALUMET

Salt Creek

Deep

River

(SAC)

INDIANA

LAKE CO.
PORTER CO.

SAUK

0 1 2 3 4 5
Miles

Chiqua's Town

TRAIL

Clark R.

In 1833, the Calumet Region was crisscrossed with trails that had been established for over hundreds of years by the local Indians who lived here. At least six traversed what became Portage Township.

IMAGES
of America

PORTAGE TOWNSHIP

Dennis Norman & James Wright for
The Portage Community Historical Society

ARCADIA

Published by Arcadia Publishing,
an imprint of Tempus Publishing, Inc.
3047 N. Lincoln Ave., Suite 410
Chicago, IL 60657

Printed in Great Britain.

Library of Congress Catalog Card Number: 2003101030

For all general information contact Arcadia Publishing at:
Telephone 843-853-2070
Fax 843-853-0044
E-Mail sales@arcadiapublishing.com

For customer service and orders:
Toll-Free 1-888-313-2665

Visit us on the internet at http://www.arcadiapublishing.com

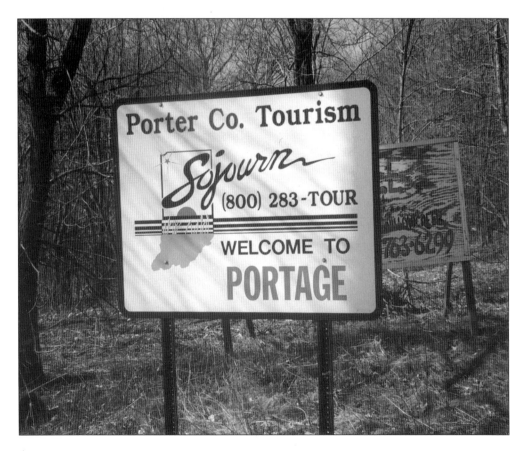

CONTENTS

One

INDIANS, SETTLERS, AND EARLY HISTORY FROM 1830

L ong before the early settlers moved into Porter County, the Pottawatomie Indians inhabited this land. Chief Pokagon was at one time in his life a diplomat working for the United States Government as an ambassador. Pokagon realized early on that the white man would come to this land by the shores of Lake Michigan. For the Indians, this meant that they and the settlers would have to work and live together. The younger Indians were restless and wanted to use war rather than diplomacy against the white settlers. In 1812, Chief Pokagon sold Indian land to the settlers. This land is now known as Gary, Indiana. Garyton area was the main Indian settlement when early settlers arrived. Chief Pokagon visited there often.

By 1834, the Indians were gone and the settlers started businesses, farmed, and hired out their various skills, which included blacksmithing, quilting, and carpentry. The settlers included many who came from eastern Pennsylvania and Virginia looking for more land and opportunity. In addition, a group of immigrants from Sweden headed west after arriving at Castle Garden and later Ellis Island, New York. These Swedish settlers came in relatively small numbers at first, but the number grew substantially by the turn of the last century. The end of World War I heralded a new influx of immigrants from England, France, Ireland, and Germany. Many of the Irish worked on the railroads laying timbers and driving spikes.

The land offered rich soil for farming, a good source of drinking water, and lakes and streams with an abundance of fish. The grasslands were plentiful to raise dairy and beef cattle. The forests yielded plentiful deer and other wildlife that were a source of food, clothing, and furs for trading.

Northwest Indiana would draw people because of the abundant resources. Yet, not everyone found a paradise here. The winters could be brutal for some, and the young and the elderly were the most vulnerable to illness and disease. Those that endured the hardships would prosper. As the people prospered, so would this land of Porter County. Communities grew in a big way in the 1880s and into the early 1900s due to the railroads. The building of the St. Lawrence Seaway opened the Great Lakes to the world, and the creation of the Port of Indiana in the late 1970s literally brought the world to the young Northwest Indiana city known as Portage.

The Indians who inhabited these lands had lived here for hundreds of years before the white man came. They hunted wildlife that abounded in this area and made simple tools from rocks

and trees. They crafted arrows and spears for hunting and made clothing and moccasins from animal hide. Their children learned these survival skills at early ages. They played simple games and rode ponies for recreation. There was at least one Indian settlement north of Crisman at Route 20. An Indian burial site was found where the Shell station is now located on the southeast corner of Route 249 and Route 20. Other Indian artifacts have also been found throughout the area at excavation sites and wooded areas. Even though Indians haven't lived here for almost 175 years, their presence continues to surface from time to time as a reminder of their existence.

Many descendants of those early settlers can be found in the community. Families such as Fifield, Swanson, Samuelson, Crisman, Lenburg, Robbins, and Nicholson are as vital a part of the area as their ancestors were before them.

The growth of the area came about slowly. Before the steel mills, only about 100 years ago, Portage Township's growth had remained fairly static and rural. The area was just too far from Chicago and other business or destination points. The railroads ran through this area and there was one train depot, but as the railroads streamlined their operations, the whistle-stop depots became a thing of the past.

The advent of the steel mills in both Lake and Porter Counties brought jobs and commerce to the area in increasing numbers. Housing, businesses, schools, and services were suddenly in great demand. The concurrent invention of the electric light and the automobile generated even more opportunities and paved the way for more visitors. Chicago was now much closer and accessible. It was not much longer before U.S. Highways 6, 12, and 20 would cross the township to accommodate the growth. When those proved insufficient, Interstates 80, 90, and 94 were added.

In about 200 years, what had once been Indian land and farmland evolved to become an international business center and a recreational bonanza. With a population of over 35,000, Portage Township with the City of Portage as its heart, leads the county in number of residents.

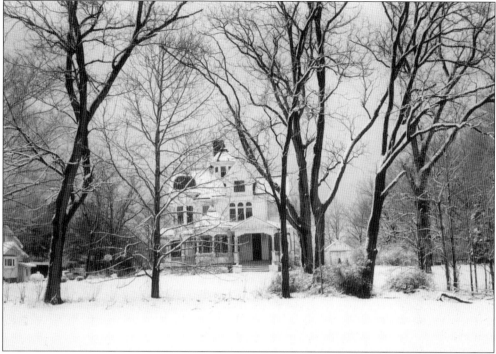

This stately Victorian-style home was built in 1887 and was owned by the Robbins family. It stood on Robbins Road across from the present Robbinhurst Golf Course. Unfortunately, it no longer exists today.

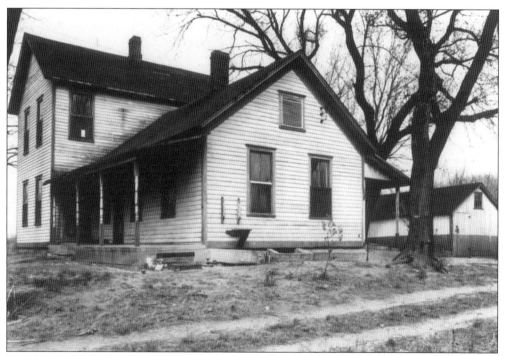

The Sargent/Nicholson home is seen here as it looked years ago.

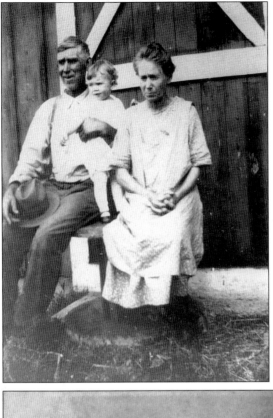

Charles and Elizabeth Trager are pictured here with their granddaughter, c. 1927.

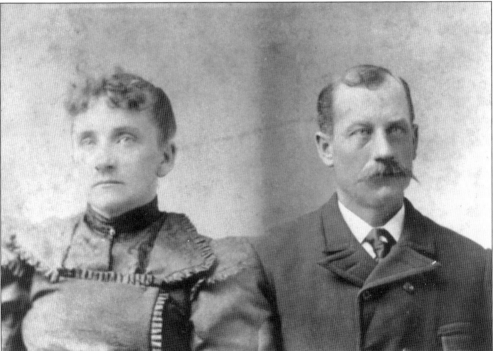

This sober-looking picture of Mr. and Mrs. William Trager was quite typical of the period. Smiling was not the accepted image to project, and they sat at an angle from each other.

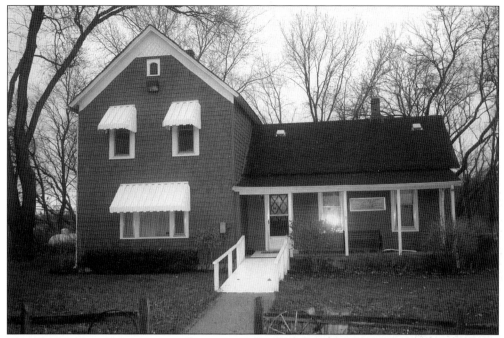

The Charles Trager House is now "home" to the Portage Historical Society Museum. Plans call for a new museum to be built, which will allow the home to be restored to the farmhouse it was in 1910.

A windmill stands as if in defiance of the depletion of farmland. New home subdivisions replaced most of the farms that were once predominant north of Highway 6, and the process is now proceeding between Highway 6 and Co. Rd. 700 N.

The August Trager Home is earmarked to be torn down for commercial development proposed for the north side of Highway 6 just to the west of Countryside Park.

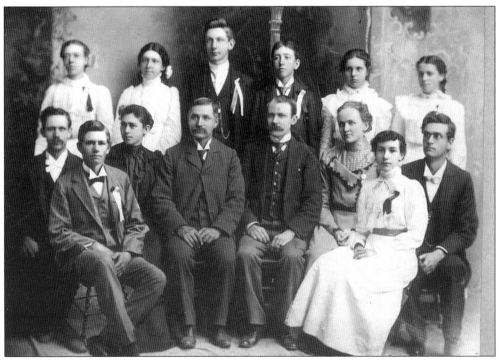

The Robbins Family gathered for this photograph in the early 1900s. Edith Robbins (top row, second from the right) graduated from grade school at the family farm.

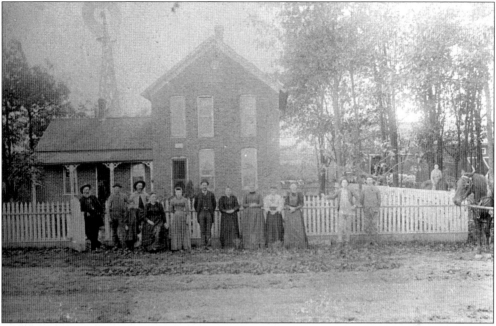

The Jacob Lenburg House was built in 1874. It has undergone renovations and additions over the years but still bears the year prominently in front. It still stands on Central Avenue at the corner with Airport Road and is now the parsonage for the Christian Assembly Church next door.

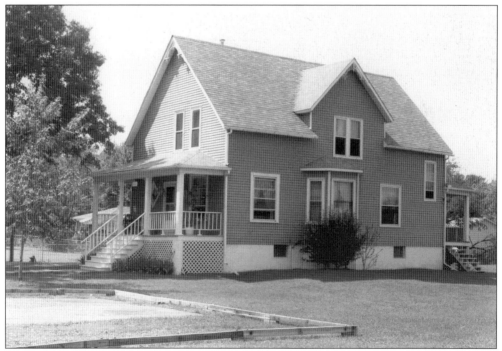

From its location on Willowcreek Road, the Leonard Crisman Home was moved to 5970 Lexington on land that was owned by Milton Crisman. The property, also known as the "Mink" farm, stretched from Central Avenue to Mulberry along Willowcreek Road.

Morton Crisman built this home in the early 1900s for his second wife, Minnie Grimmer. Its address today is 2140 Crisman Road.

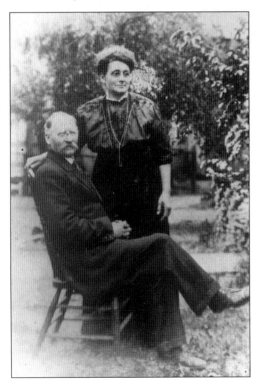

The Herbert Scofield family owned the grocery store in Crisman. True to the photo etiquette of the time, the man sat and the lady stood behind.

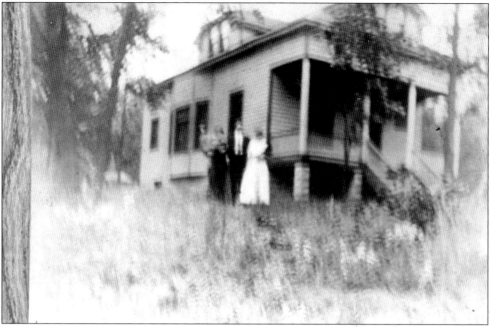

In 1914, Helmer Brandt constructed this home at the corner of Central Avenue and Swanson Road. In the 1950s, his son Fred opened a hardware store just east of the home on Central Avenue. It was in operation for over 40 years.

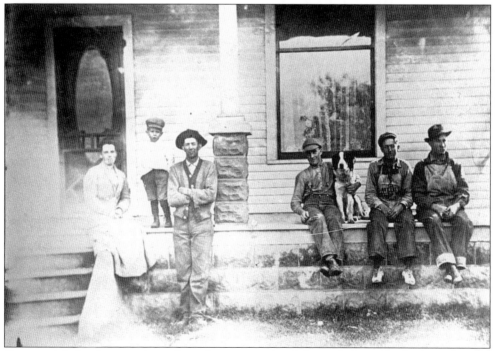

Commercial development has taken place on much of this early Lute family farm. George, Grace, and their son Ben stand proudly by their home and some of their farmhands. The remaining land is still farmed by Phil Lute today.

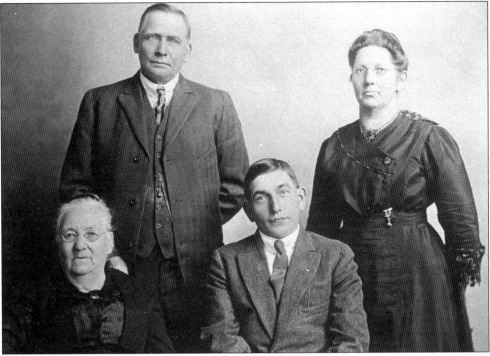

Family photos were very popular with the early settlers, and they provide an excellent window into how they lived. Here we see Eugene Fifield and his wife, Mary, standing with son John and Eugene's mother, Lana.

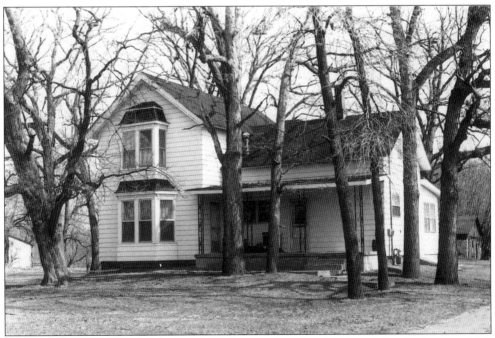

Across from the Nazarene Church at 3151 Swanson Road is the Conrad Bender house, which was built in 1893. Currently the "home only" is for sale.

Pictured are Ralph Blair and his daughter Emily along with the family cat.

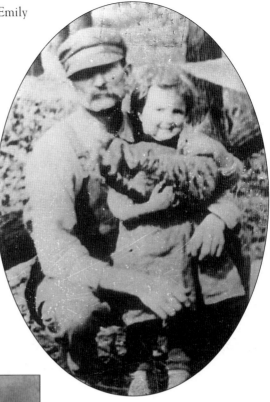

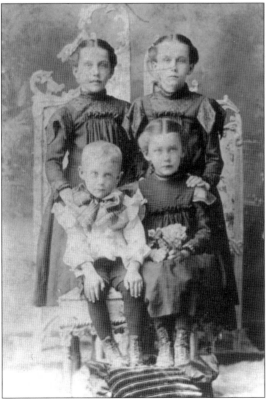

Old photographs capture more than just a person's looks. They are also a valuable record of what was fashionable in dress and appearance. Notice the matching outfits being worn by the Trager children, Elsie, Lena, Tressie, and Bill. Check out the lacing on the shoes too.

A variety of fashions are evident in this family photo of the Herbert Scofield family.

It was 1876, America's Centennial, when the William McCool House was built at what is now 7106 Lenburg Road.

Chief Leopold Pokagon was a voice of reason for the Pottawatomie Indians. They lived in the dune lands of Lake Michigan. He convinced the elders that warring against the white settlers was not in anyone's best interest. Although the Pottawatomie tribe did help in the attack on Fort Dearborn in Chicago, it was only part of the group, generally the younger members, who participated. Chief Pokagon was in Michigan and returned too late to stop the Fort Dearborn Massacre. However, he did speak out against the use of alcohol and became very religious.

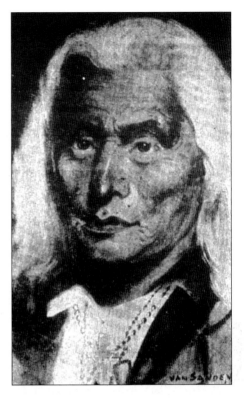

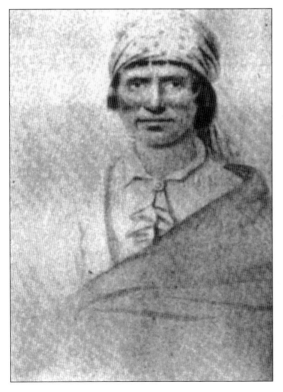

Chief Ashkum had a camp on what is now U.S. Steel property in Gary. He sold the property for $1.25 per acre and moved his tribe to central Illinois. He left Indiana feeling regretful that Indian dignity had been sacrificed. Ashkum was one of 60 chiefs who reluctantly signed the Treaty of Mississinewa in 1826. They left the area in 1834.

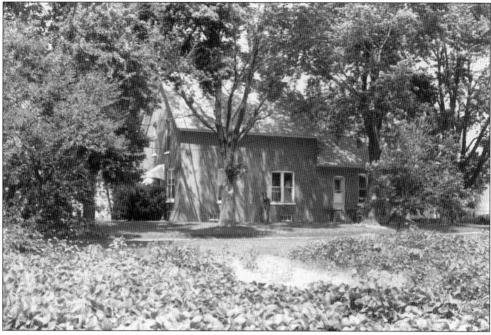

The Heinrich (Hy) Schlobohm house was built in 1900. It is located at 741 N 500 W.

Maria Dombey stands proudly in front of her house. Although of simple construction, the Christ Dombey house projected its own personality with the porch railings and gingerbread under the porch roof.

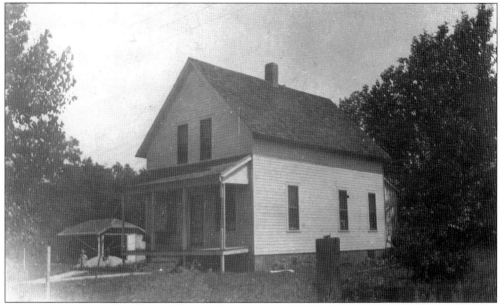

The Rudolph Jannasch home on Portage Avenue is another landmark home in the township. It was once used as a boarding house for B & O (Baltimore & Ohio Railroad) employees.

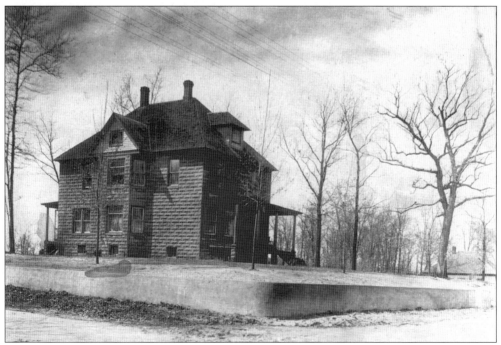

This fine example of a great family home is the Charles Jannasch house, which once stood at the corner of Hamstrom and Portage Avenues. The three-level bay window and deep pitch of the roof line are very distinctive. It also had a cellar, the forerunner of our modern-day basements.

Typical of the architecture from 1910 through the 1930s is the Paulding home, located at Central Avenue and Swanson Road.

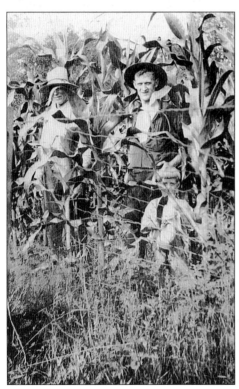

Charles Trager, left, with Papa Wall and boy Wendell are looking onto Route 6 from the Trager cornfield in this 1923 photo.

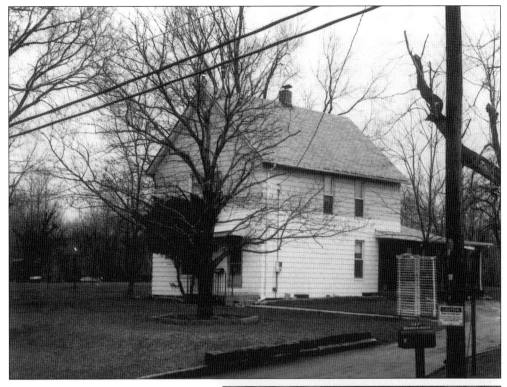

Originally a log cabin in 1867, the Andrew Anderson home was later added on to and covered with wood siding. Anderson, his wife, and four children left Sweden by boat, a nine-week trip. After visiting friends in Andersonville (located on the north side of Chicago), his family took the Pennsylvania Railroad to Hobart. He rented a farm in Lake Station and cut wood for the Michigan Central Railroad. The family moved into this home in 1867. Anderson and his daughter Clara viewed the body of President Abraham Lincoln as it passed through Lake Station on April 14, 1865.

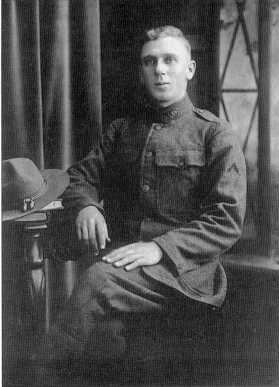

Alvin Swanson is pictured here in 1914 in his World War I uniform.

The Frank Severance home was built in 1912 at a cost of $3,380. This included sidewalks, acetylene gas lighting, and boiler hot water heat. Victor England, a neighbor, helped Frank with the construction.

W.A. Briggs moved to Portage in 1894 and married Rose Lambert in 1895. They originally lived at 6193 Federal, right next door to this house at 6207 Federal. In 1901, they moved into this house. Briggs was a school teacher for 27 years and the first principal of Crisman High School.

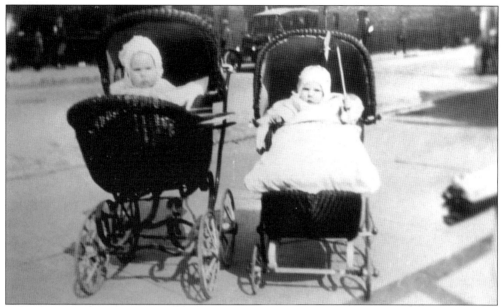

Marie Griesinger and Hazel Buhman Nagy ride in style in their wicker carriages.

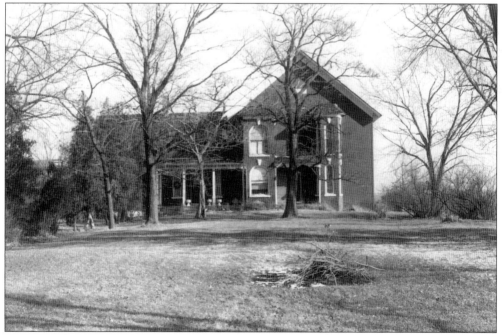

A stone at the peak of the roof gable on the front of this house testifies to its construction in 1890. Originally built by Elmer Wolfe, the son of Josephus Wolfe, the house is now owned by the Martin Marvel Family. It stands impressively at the corner of Wolfe Road and Co. Rd. 600 N.

The Blake House at 5869 Central Avenue was built by Franklin and Lucy Blake, probably in the 1840s.

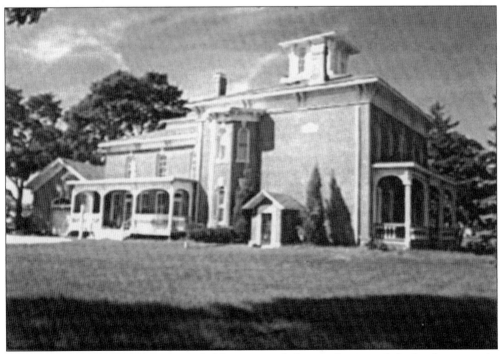

The Josephus Wolfe Mansion, a stately Victorian-style home, dominated the landscape on its rural corner of 700 N and Wolfe Road.

All that remains of the Hamstrom Farm at the crossing of the toll-road overpass and Hamstrom Road is the house and an out building. Norm Hamstrom lives next door to the home on original farm site property.

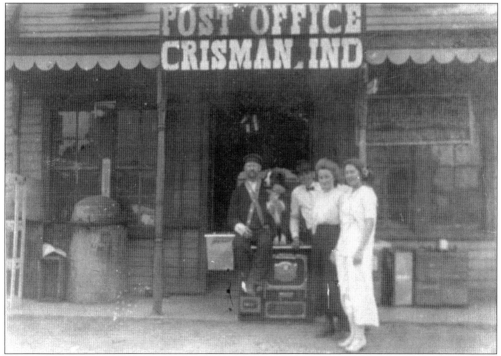

Burl Hall, the man on the left, is the last known trapper in the area. He lived above Scofield's General Store in Crisman.

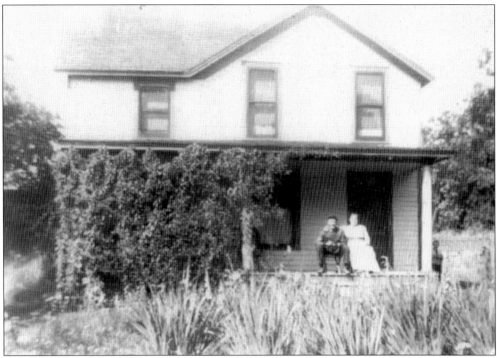

John and Pauline Krieger used their front porch for this 1920s picture. The front porch was a functional addition for most homes in an age prior to air conditioning. Here they could reflect on life and greet passing neighbors.

Located at 6714 Central Avenue, the Fifield Home was distinguished by its barn-like roof.

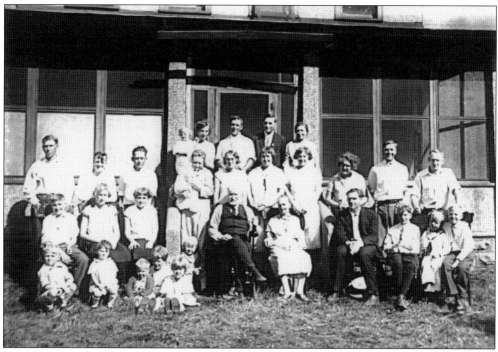

Peter Nicholson's family poses proudly in front of their home in this 1920s picture.

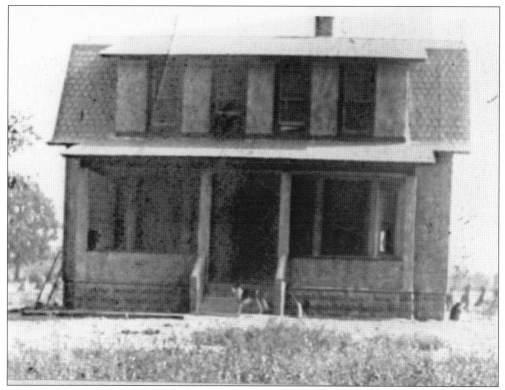

The Ben Crisman Home at 2083 Crisman Road was later sold to Peter Nicholson.

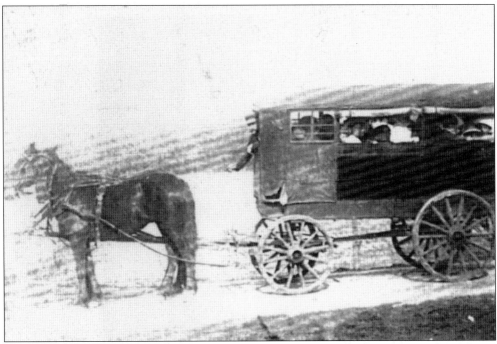

This 1917 vehicle was Portage's school bus. The driver was Al Sargent, shown here near U.S. 20 and Crisman Road.

Old photos not only capture people but also the fashions of the time. The watch chain was a finishing touch on the four-button suit with vest and stovepipe pants.

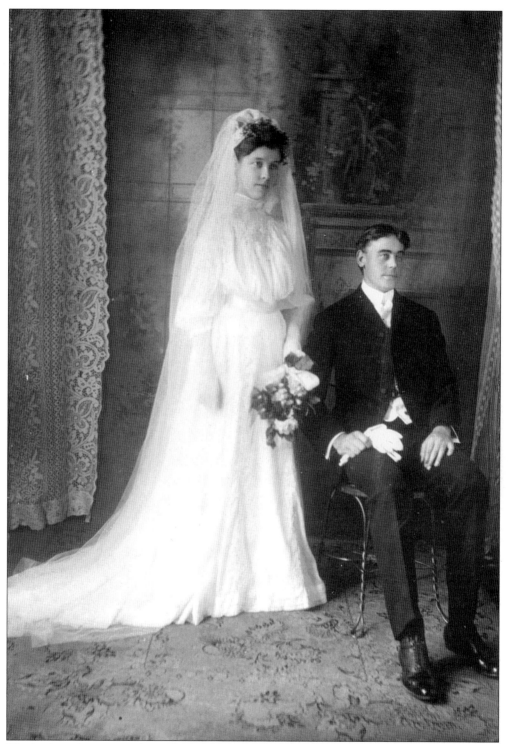

The bride and groom in this early 1900s picture are both wearing very stylish outfits.

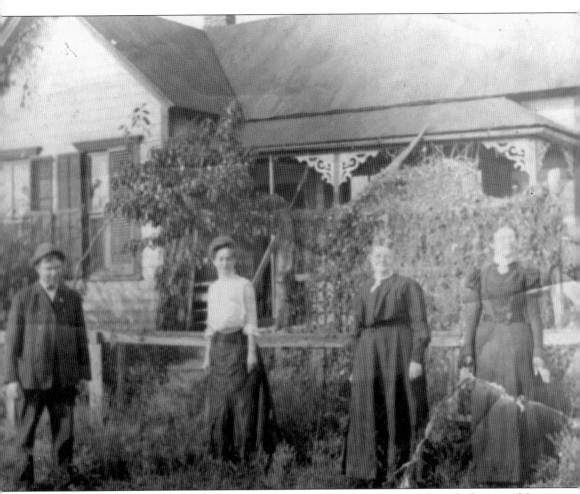

At the Crisman Station, from left to right, are a railroad tower man, Rose J. Goering, Mrs. Graham, and Mrs. Hannah Crisman.

TALE OF FOUR TOWNS

The City of Portage is still a toddler as far as cities go, even if it is now 35 years old. Portage actually is composed of four separate little villages that sprang up in the early 1830s. Crisman, McCool, and Garyton are still identified as distinct neighborhoods or districts within the city. The fourth area near the shores of Lake Michigan was known as Dunes Park which no longer exists.

The first focus for Portage's development was McCool. Located along McCool Road, it stretched from Central Avenue on the south to the curve onto Portage Avenue on the north. One of the first churches in the area was the McCool Methodist Church. The building was torn down after the existing First United Methodist Church was built. McCool also boasted a Reo dealership. Reo initially made automobiles, but they found their niche in building trucks, including fire trucks (speed wagons). Reo continued making trucks into the 1960s, and a famous 1970s rock n' roll group even took the name. McCool was the first community with a rail siding for the train delivery of goods for the general store and granary. The train siding and warehouse depot operated where Rico Sign Art is today. The village of McCool also boasted a general store and post office and hosted the business community to the east. Today there are still some small local businesses along McCool Road plus the Ethel Jones Elementary School and one of Portage's largest parks, Imagination Glen. This park hosts soccer, softball, BMX, and fishing along Salt Creek. In early spring, the Coho salmon run can be seen at Salt Creek. The park also offers a great walking trail with spectacular views each autumn.

Just to the west of McCool on the B & O Railroad at Samuelson Road is Robbins Pond and the one-lane viaduct, a pleasant reminder of days gone by, except at rush hour.

A little further to the west, about a mile, was the site of the little community of Crisman at the junction of Crisman Road and Portage Avenue. Anyone arriving by train about 100 years ago could step off the train and take a room at the boarding house located there. Crisman offered a high school (built in 1909), Scofield's store, and one of the mink farms in the area. Scofield's featured a post office, dry goods, fresh meat and vegetables, and hardware items as well. The last known fur trader and trapper lived over Scofield's store. The train crews would often stop and have meals at the boarding house.

The Nicholson family owned the Crisman Sand Company, a thriving business during the

construction of the early highways and the toll road. The abundance of sand helped keep the cost of the toll road down when it was built. The sands of the dunes at one time extended all the way south to U.S. Highway 6, more appropriately known as Ridge Road.

About one mile west of old Crisman is Garyton. Garyton was a community of small cabins that the wealthy owned and would use for vacation and weekend retreats. Many of these homes can be seen north and south of Mulberry Avenue from Willowdale to the County Line. Public transportation brought people from Chicago, Hammond, and Gary to Garyton.

The Dunes Park area was primarily a summer retreat for the well-to-do in Chicago and surrounding area. Situated between what are now National Steel and Bethlehem Steel, it hosted a world-class ski jump in the early 1900s. People came from all over the country to compete in the events. The Depression of 1929 brought the activities and planned growth to an end. Today it is little more than a memory. After WWII though, there was renewed interest in the shores of Lake Michigan by wealthy people from Chicago looking for a place to build summer retreats and homes. The area selected was property to the west of National Steel which was called Ogden Dunes. For years it was one of the first and only gated communities. Known for its imposing homes and magnificent waterfront properties, Ogden Dunes continued to retain its separate identity even after it was incorporated into the City of Portage. Now a year-round home for most of the residents and the only stopping point for the South Shore commuter railroad in Portage Township, it remains very upscale and exclusive.

Garyton, Crisman, McCool, and the addition of Ogden Dunes delineated the shape and size of first the Town of Portage and later its city limits. With the growth and expansion of the city, the former boundaries and open areas between them have long disappeared except in the memories of the city's older residents.

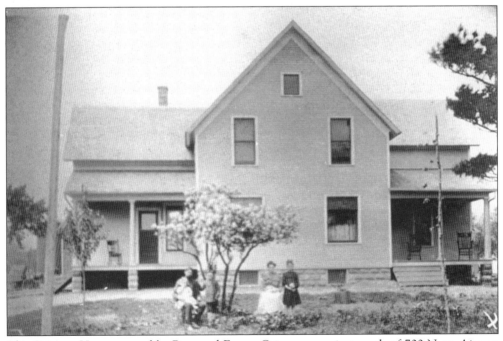

The Crisman Home, owned by Ross and Emma Crisman, was just south of 700 N on Airport Road.

The John Kuehl Farm, built in 1903 at 655 N 625 W, was sold in 1947 to Ervin Gottlieb.

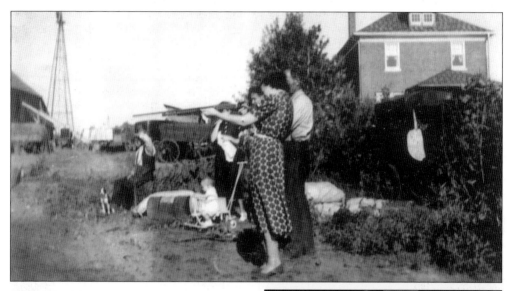

Deer and rabbits were a primary meat source for the early settlers. Some target practice was common on the Erwin Ewen farm in the 1930s.

Erwin Ewen (left) poses with his soldier son, John Ewen.

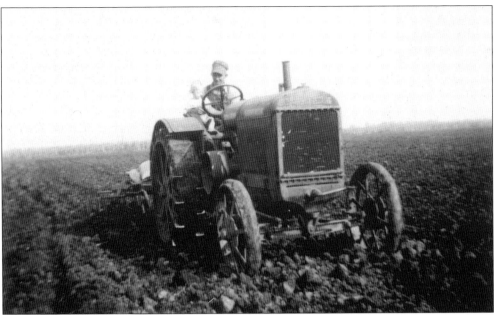

Carl G. Hinderer and his son Carl E. are shown in this 1939 photo atop their 1920s tractor with its steel wheels.

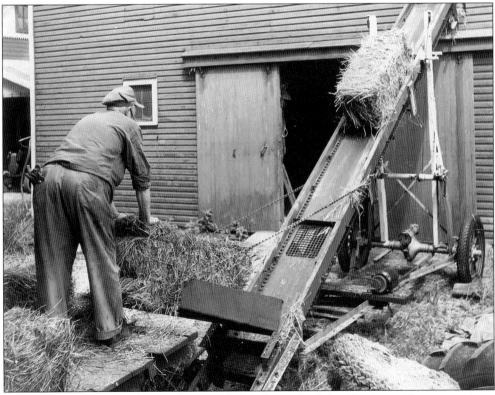

George Samuelson is hard at work storing hay bales in the loft of his barn. Hay was a winter staple for his cattle.

Carl August Asplund, pictured here in his barn about 1924, was born in Sweden in 1849 and died in 1927. He was married to Joanna Sophia Blomquist. Their farm was located in Garyton, and they are both buried in Blake Cemetery.

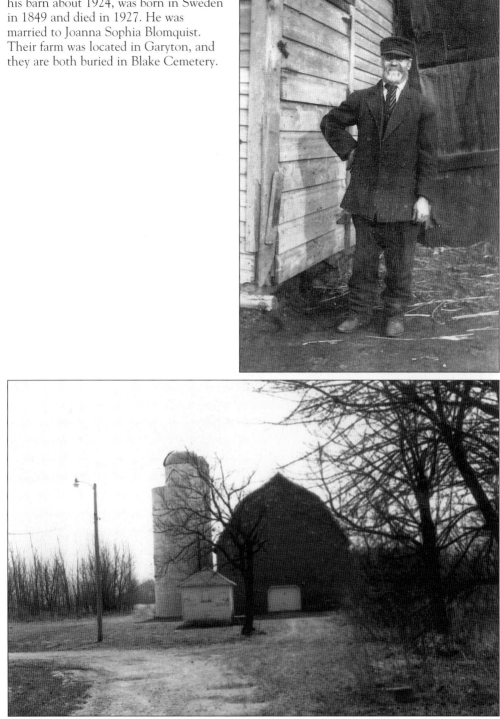

This Dutch-style red barn was typical of Midwest barns. With its grain silo for storage of corn, they were a distinctive part of the landscape in the first half of the 20th century.

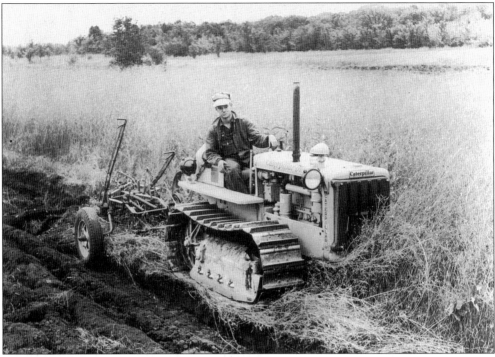

Fred Himebrook is plowing part of the Robbins Farm in this 1940 picture. Located at the southeast corner of Highway 6 and McCool Road, this is now the site of South Haven.

Area farms in the early 1900s were much like this one, the Samuelson Farm at the northwest corner of McCool and Portage Avenues.

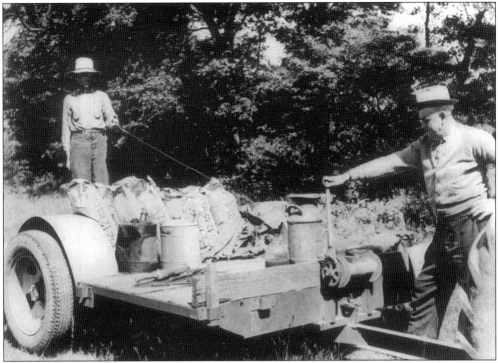

Carl Hamstrom (left) and George Samuelson are seen in this 1948 shot getting ready to spread fertilizer. Those are 12-12-12 bags on the trailer.

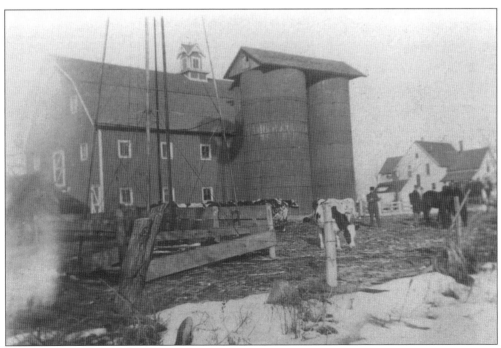

The Crisman Farm was another farm with a great barn featuring a distinctive cupola on the roof top. Built in 1904, it was struck by lightning and destroyed in 1935.

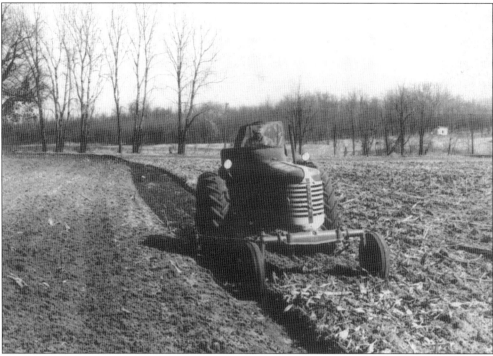

The field being plowed by Erwin Ewen is now I-94, and the tree line in the background is part of State Road 249.

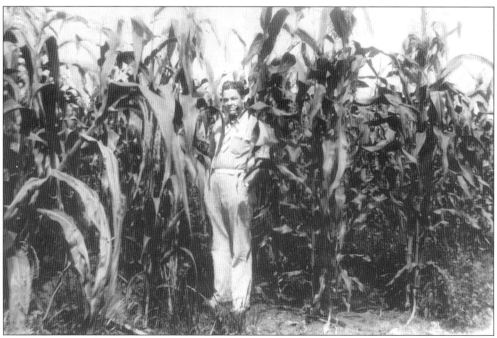

Glen Swanson is standing in his own "field of dreams." Do you think this corn was "knee-high by the 4th of July"?

Swanson House, located at the corner of Swanson and Stone Avenues, was once used as a school house in the early 1900s.

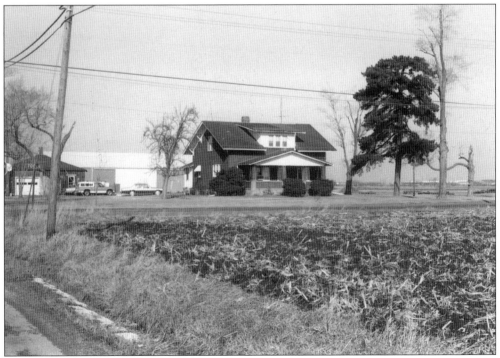

This bungalow-style home was built *c.* 1920 by George Haxton. The farm was known as the Maple Row Dairy Farm.

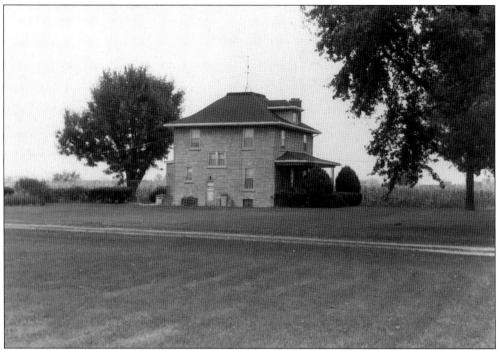

The Arvilla Dairy Farm was constructed by Levi Bay in the early 1900s at 700 N 659 W. It was purchased in 1947 by the Leininger family who owned it until 1999.

The U.S. Postal Service would have trouble delivering mail to this address today. This winter scene is the Lute farm whose address was RFD I–Box 85, Gary, Indiana. (Notice there was no zip code.)

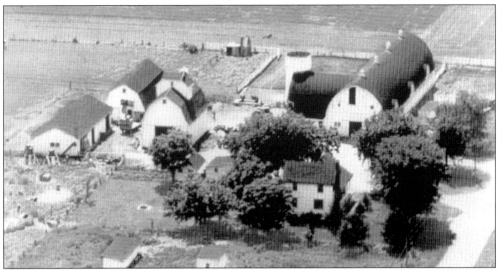

One of the prosperous farms in this area can be seen in this aerial view of the Raymond Lute Farm.

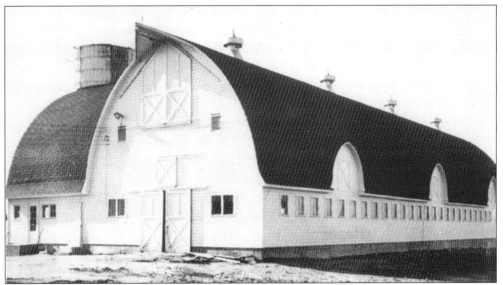

This photograph of the Lute's German/Dutch-style livestock or dairy barn shows many of its uses. The doors at the top were used for loading hay, and the small windows indicated it housed livestock or dairy cows. Many a barn dance was held in the hay loft.

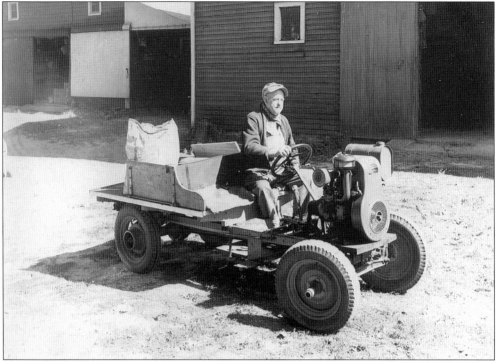

George Samuelson is shown here with his homemade "Doodlebug" in 1948. George also manned the first McCool Airport at McCool and Robbins Road.

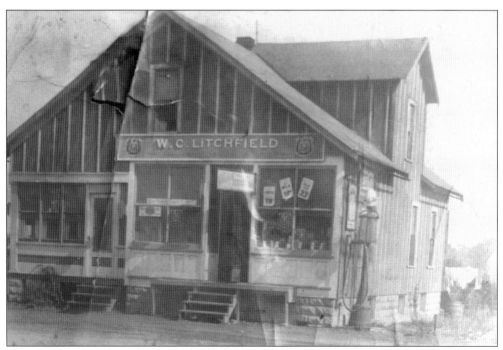

W.C. Litchfield's store was in McCool. Its old glass-top gas pump was a standard fixture at this time and made "pumping gas" a very true term..

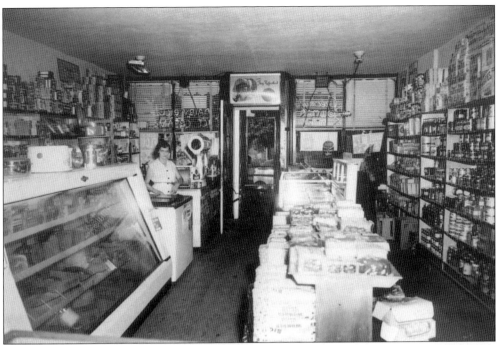

Inside the Litchfield Store, canned goods lined the shelves (right and top left), with a meat counter (left) and baked goods in the center. Some of the brands, like Wonder Bread, are still around.

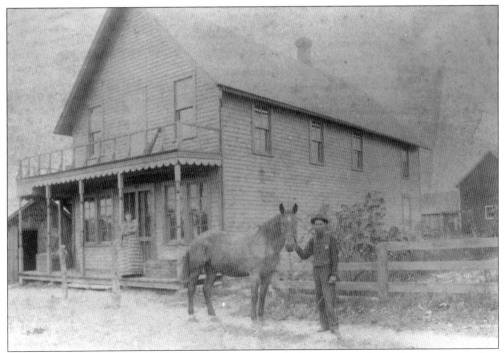

The best way of getting to the store was on horseback for many residents. Here is one tied up outside the original Scofield Store.

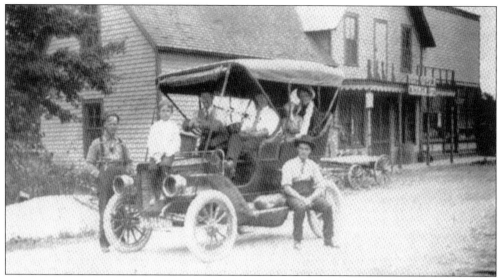

Automobiles before WWI were sometimes called "Brassies" because of the brass trim, handrails, and headlights. The wagon in the background was becoming a thing of the past. Also evident are changes that had been made to the Scofield Store in Crisman by 1915.

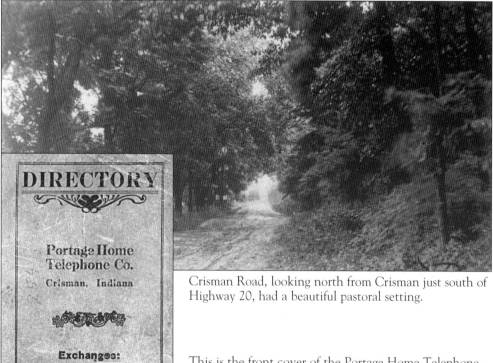

DIRECTORY

Portage Home
Telephone Co.

Crisman, Indiana

Exchanges:

WHEELER, INDIANA
CRISMAN, INDIANA
CHESTERTON, INDIANA
WESTVILLE, INDIANA
ALSO
UNION MILLS EXCHANGE
of the
Northern Indiana Telephone Company

Crisman Road, looking north from Crisman just south of Highway 20, had a beautiful pastoral setting.

This is the front cover of the Portage Home Telephone Company book for August 1, 1911. It included listings for the Union Mills exchange of the Northern Indiana Telephone Company, and calls could be made from here to Westville. The Portage Home Telephone Company started in 1903.

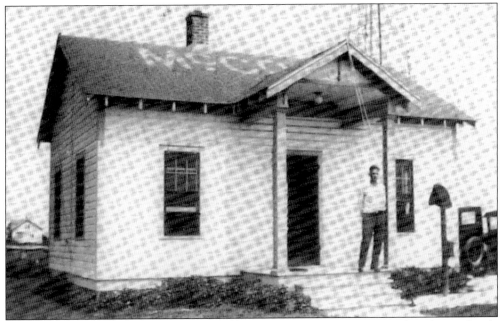

The Civil Aeronautics Administration (CAA) station stood on Airport Road on the north side of Highway 6. Contrary to some beliefs, the government built the airport as a training station. In addition to training, the field also offered defense, mail service, and a public landing site.

W.A. Culbertson is pictured inside his McCool Grocery in the 1940s.

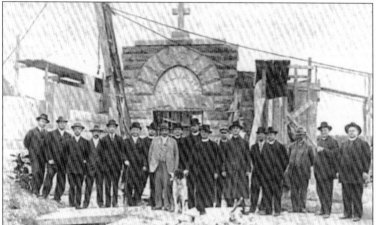

This postcard from Dune Park, Indiana, was sent to George Samuelson and is postmarked March 17, 1911.

The city's largest cemetery, Calvary, is located at Willowdale Road and Central Avenue. Here it is under construction.

"Greetings from Crisman, Indiana" is on the back of this postcard, which is postmarked December 22, 1914.

Three

CHURCHES AND

ORGANIZATIONS

Religious beliefs have been a hallmark of the many different groups that moved into Portage Township, and churches were built here beginning in the mid-1800s. They reflect the diversity of nationalities and beliefs that make up the community. The current edition of the Greater Portage Chamber of Commerce lists 39 churches.

The McCool Methodist Church (now First United Methodist Church) is located at 2637 McCool Road, and it was the first church in the township. In 1969, the Methodists, Methodist Episcopal, United Brethren, and Black Methodist churches united under one umbrella as the First United Methodist Church. The Portage church continues to grow and now boasts three Sunday morning services. Listed among its members are long-time area family names such as Crisman, Samuelson, and Lenburg.

It was primarily Swedish immigrants who moved into the Garyton area from the Miller area of Gary and the north side of Chicago who started the Garyton Covenant Church. The church stands on Central Avenue one block east of County Line Road. This is their fourth building; twice the church was consumed by fire. At one time it also operated a very popular and much admired parochial school for pre-school and kindergarten students.

The Nazarenes have had two churches in Portage for some time: the north side church on Clem Road, and a church on the south side on Swanson Road two blocks south of Stone Avenue. The Swanson Road group has gone independent. Now known as the Real Life Community Church of the Nazarene, it is one of the fastest growing churches in Portage.

The Presbyterians are represented by two very active congregations in the community. One is the First Presbyterian Church at 6225 Lute Road and the other is the Ogden Dunes Community Church-Presbyterian.

The largest church and congregation in Portage—and one of the most active—is the Nativity Catholic Church. Bingo and fish fries are just some of the things the church does for members and the community as well. Their annual summer festival is the most extensive and well-attended event in the city. Nativity also operates a parochial school for kindergarten through the eighth grade.

With nine churches representing the Baptist faith, the number reflects the generally fundamental nature of the residents.

The Christian Church, the Church of God, and a few other evangelical churches are also present. The South Haven Christian Church and the Portage Christian Church also run parochial schools for students from kindergarten to twelfth grade. They are the only Protestant schools in the township.

Some of the German heritage in Portage is evidenced by the three Lutheran churches that have been here for many years. Hope Lutheran Church, now independent, was formerly a member of the Evangelical Lutheran Churches of America and is located on Portage Avenue just west of Hamstrom Road. St. Peter's, a Missouri Synod Lutheran Church, is located just east of Airport Road on Central Avenue. The third Lutheran church of worship is Holy Cross Lutheran, also Missouri Synod, located on Route 6 between Swanson Road and County Line Road.

The rapport that exists among these different churches is indicative of the tolerance found in the community.

Portage Township is also home to over 25 civic organizations and patriotic groups. Both South Haven and Portage have thriving American Legion Posts and their own Boys and Girls Clubs. Ogden Dunes, Portage, and South Haven each has its own Lions Club, while Rotary International, the Exchange Club, Kiwanis, the Moose, and the Masons have chapters in Portage. There are also groups like the Hunt Club, the Garden Club, and Isaak Walton League. Add a very active Tri-Kappa Sorority chapter, a Salvation Army post in South Haven, and a popular YMCA, and it becomes obvious how much community involvement is a part of the fabric of the area.

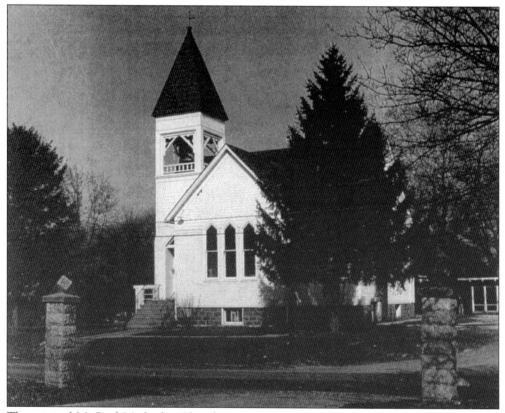

The original McCool Methodist Church, pictured here, was the first church built in Portage Township. It was later torn down when the existing building for First United Methodist Church was erected.

Portage has had a Rotary Club for over 40 years. This is the cover from their Charter Night. Rotary is an international service organization, and the local chapter remains very active.

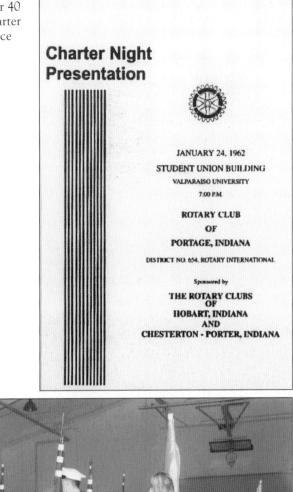

Charter Night Presentation

JANUARY 24, 1962

STUDENT UNION BUILDING

VALPARAISO UNIVERSITY

7:00 P.M.

ROTARY CLUB

OF

PORTAGE, INDIANA

DISTRICT NO. 654, ROTARY INTERNATIONAL

Sponsored by

THE ROTARY CLUBS
OF
HOBART, INDIANA
AND
CHESTERTON - PORTER, INDIANA

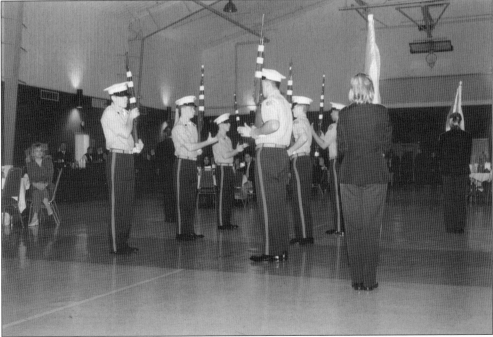

The Portage High School ROTC Rifle Drill Team has earned a national reputation for its routines. Sponsored by the Marine Corps, leadership is a primary focus.

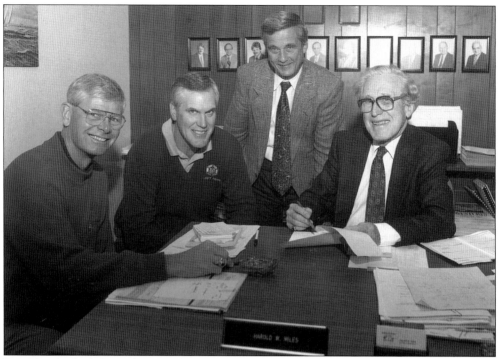

Harold Miles (right) was director of the Greater Portage Chamber of Commerce until 2002. After a brief stay, John Leander stepped down and Terry Hufford was appointed in October 2002.

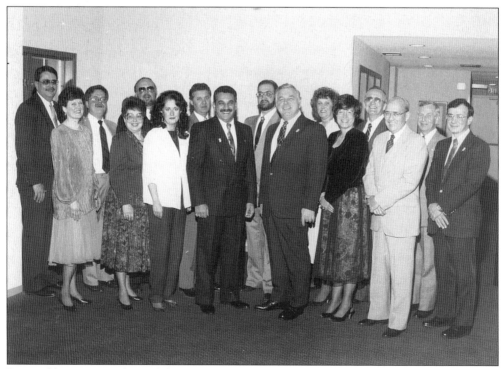

Pictured here are members of the Chamber of Commerce Board of Directors in 1992.

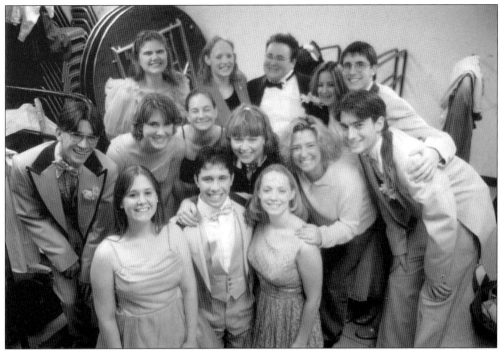

The Portage Community Theater Group has brought entertainment to many with its talented members.

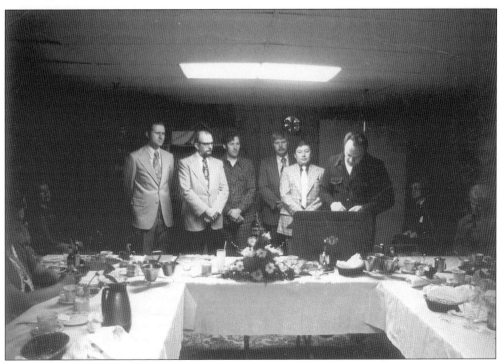

Chartered in 1956, the Portage Lions Club is part of the largest service club in the world. Here is the installation of new officers.

Garyton Boy Scout Troop #32 celebrates their Father-Son Night in 1957.

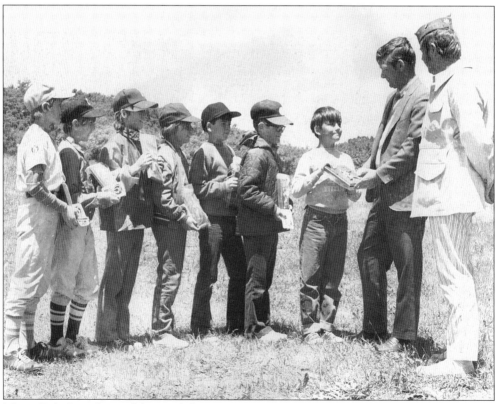

Mayor Bob Goin (second from right) is presenting awards to the winners of the Portage Little League Pitch, Hit, and Throw competition in 1972.

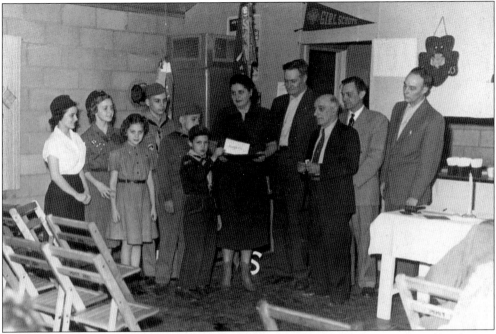

Here is a picture of the Mortgage Burning Ceremony in 1954 for the clubhouse used by the Boy Scouts and the Girl Scouts.

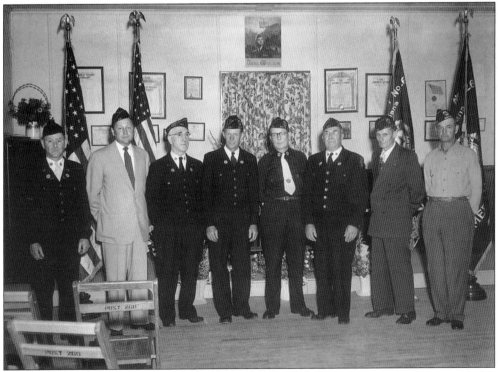

The officers of the American Legion Post #260 proudly pose in this picture. The Legion holds fish fries, breakfasts, and their annual picnic, Portage's largest one-day event.

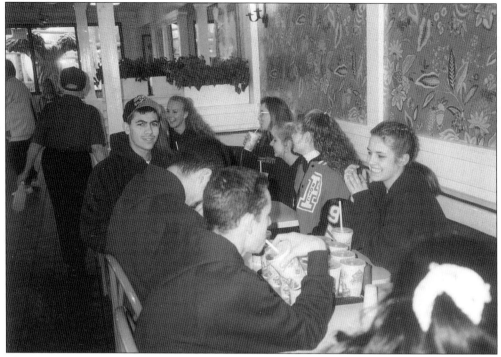

The Portage High School JROTC program has developed an impressive reputation with their drill teams and their involvement in community activities. Here are some of the cadets having lunch at McDonald's after helping the Portage Lions with a Candy Day fundraiser in 2000.

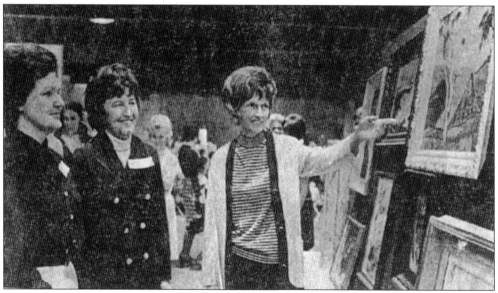

Tri-Kappa Sorority's Art and Card Luncheon was attended by Mrs. Robert Goin (right), Mrs. Robert Lands (center), and Mrs. George Jefferson (left). Still an active organization in the community, they raise money for many charitable causes. A current major fundraiser is the sale of daffodils for the American Cancer Society each spring.

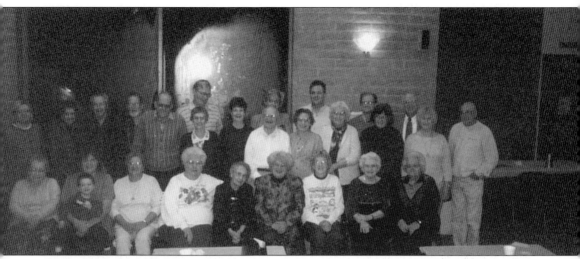

The Portage Community Historical Society, founded in 1988, will celebrate its 15th anniversary with the opening of a new museum.

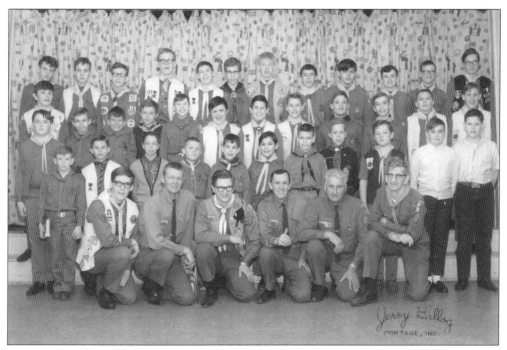

Portage's Boy Scout Troop #32 is assembled in this 1968 picture.

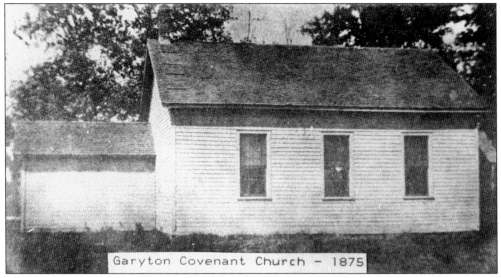

Garyton Covenant Church - 1875

The original Garyton Covenant Church was built in 1874 and destroyed by fire in 1929. For some time it was known as the "Swedish" Church because it was started by Swedish families who were seeking to break away from the traditional Lutheran Church.

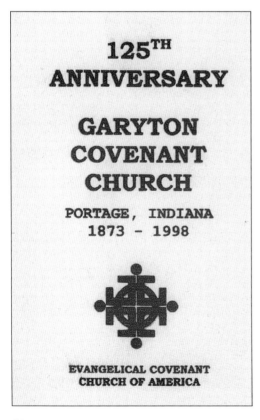

125TH
ANNIVERSARY

GARYTON
COVENANT
CHURCH

PORTAGE, INDIANA
1873 - 1998

EVANGELICAL COVENANT
CHURCH OF AMERICA

This is the front cover for Garyton Covenant Church's 125th anniversary brochure. The current church is the fourth building constructed on this site on Central Avenue just one block east of County Line Road. Two of the previous structures, located on Blake Road, were destroyed by fire.

Four

THE RAILROADS, TRANSPORTATION, AND MAJOR INDUSTRY

The railroads, the Port on Lake Michigan, and major industry have played an important part in Portage's growth and development.

By the 1870s, railroads were bringing goods and people to Northwest Indiana. Railroads that came through the greater Portage area were the Michigan Central, which ultimately would be bought out by the New York Central, and the B & O (Baltimore & Ohio) which crossed Portage from McCool past Woodland Park. The Willowcreek Massacre, as it was called, occurred at the B & O crossing at Willowcreek Road. B & O workers fought against New York Central workers and a melee broke out requiring state militia to be called to break up the workers. Ironically, in the summer of 1999 the same tracks were the subject of sabotage. Between Hamstrom Road and Willowcreek Road it was found that track spikes had been taken out just before the dedication of the new track completion project. If the missing spikes had not been detected, the ceremonial engine may have been derailed.

Today, the B & O tracks are the C & O or Chessie System. The two railroads combined during all of the great mergers of the late 1960s and early 1970s. The New York Central and Pennsylvania Railroads also merged during this time. The Pennsylvania Railroad tracks go through Valparaiso, Wheeler, and Hobart south of Highway 130. The Penn-Central, as the merger was called, was short-lived. Ultimately, the government stepped in and the doomed Penn-Central became Conrail.

Probably the best-known railway that still serves Portage today is the Chicago, South Shore & South Bend Railroad. Better known as the South Shore or Shoreline, this railway operates from Randolph Street in Chicago to South Bend, Indiana. The railway is a passenger commuter line. The South Shore has experienced service and equipment problems, head-on collisions, derailments, and money problems. The old rail cars, painted in orange and black, were sometimes known as the "Little Train That Could." The equipment was ultimately replaced by the current, longer, streamline coaches. The South Shore is powered by electricity along its journey. The South Shore does move a small amount of freight, but the bulk of its business is in commuter passenger service. Its only stop in Portage Township is at the entrance to Ogden Dunes on Highway 12.

Railroads that have been abandoned or displaced are called "ghost railways." The EJ & E (Elgin, Joliet & Eastern) is now the Prairie Duneland Trail that extends from Chesterton through Portage and presently ends in Hobart. When the last section is completed in Porter,

the trail will extend from Indiana all the way to Traverse City, Michigan. Eventually, the master plan describes a system of trails that will cross the country. What remains of the EJ & E Railroad has been reduced to running steel and Coca-Cola trains for the steel mills in Gary and switching freight from Gary, Indiana, to Joliet, Illinois, home of its operation offices.

The big difference between the trains of today and those of yesteryear is the equipment they use. The steam engines were the granddaddy of the early days of railroading. The image of those coal-burning monsters and the hollow, almost eerie, lonesome sound of their whistle cannot be imitated. The advent of the diesel engines in the 1930s ushered in a whole new period for the railroads. They were capable of moving faster, operating more efficiently, and pulling heavier loads. With the advance in technology, the current diesels are even bigger and more powerful.

During World War II, railroad traffic was so heavy through Northwest Indiana that Hammond, Indiana, was second in the world behind Munich, Germany, in rail traffic.

The decline of the railroads after World War II led to successive mergers and consolidations between competing companies. Eventually, the government stepped in with the formation of Conrail and later Amtrak. Some railway right of ways were abandoned and the tracks removed. However, the railroads rebounded. Containerized freight, increased piggy-back service (truck trailers), and the discontinuation of using the caboose on the end of the train helped bring them back. There are currently about 16 Amtrak trains through Portage every day, and, while the number of freight trains is less, their length, volume, and cargo capacity has increased tremendously.

The building of Interstate 80–90, known as the Indiana Tollway, linked Portage to Chicago as a short commute and connected the east and the west of the United States to Portage. The late 1960s and early 1970s would bring I-94 north of U.S. 20 as a route to Detroit to the east and the Northern Plains states to the west. While Portage already had three prominent highways passing east to west, (U.S. 6, U.S. 20, and U.S. 12) the limited-access interstates brought a much higher volume of potential visitors through the area. The only hindrance to making Portage completely accessible was the lack of a major north/south interstate, but I-65's close proximity helped fill that void. The only two roads that traverse the township from north to south are State Road 249 through Portage and State Road 149 on the township's east boundary.

The opening of the Port of Indiana gave Portage the keys to the world. Steel, among other things, is shipped around the world via the St. Lawrence Seaway. As one of the largest and fastest-growing harbors on the Lake Michigan shoreline, it will play an increasingly valuable role in the future business and manufacturing plans for the area.

Portage is a sleeping giant that only in the last five to ten years has begun to wake up to its true industrial potential. The building of industry along I-94 and Highway 249 at Exit 19 will continue to open Portage to the world. It will create more jobs and the need for more housing, thus stimulating more service-oriented and small business demands.

The demand for more trucking will increase,and the volume of automobile traffic in the township will increase as well. Traffic will be a growing concern, and the impending widening of U.S. 6 from County Line to South Haven will contribute to that concern. The Northwestern Indiana Regional Planning Commission (NIRPC), which has its offices in Portage, is already looking at mass transit as a way to relieve the growing congestion on the area's major thoroughfares.

Just imagine—in less than 200 years, Portage Township has evolved from explorers and travelers walking, riding on horseback, paddling canoes, and riding in horse-drawn wagons to a massive transportation center. Our forefathers did not require gas stations, convenience stores, or massive truck stops, yet today that need, combined with the hotel/motel industry, tourism is an ever growing constant in our daily lives. Portage boasts the most hotels and motels in Porter County and the largest revenues from this industry.

Portage has come a long way since the days of bartering goods and services. It is now truly a transportation and industrial mecca. The new Ameriplex development being developed on Highway 249 along the north side of the toll road is a harbinger of the prominent role Portage and Portage Township will have in the 21st century.

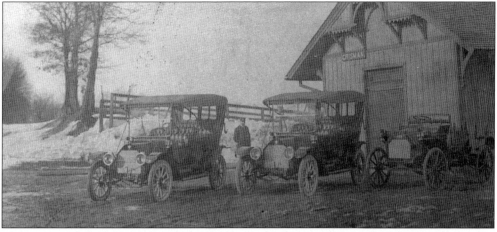

These automobiles are parked outside of Crisman Station, *c.* 1913. Little did anyone know the impact cars would have, not only on train travel but also on the world.

The industrial park south of Highway 20 is home to a number of small to medium companies such as the Smurfit Corporation, which manufactures bubble packaging material.

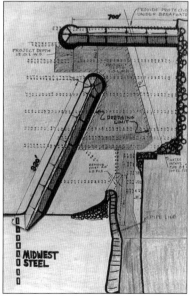

This is the engineering drawing of the breakwater and water intake of Midwest Steel Corporation.

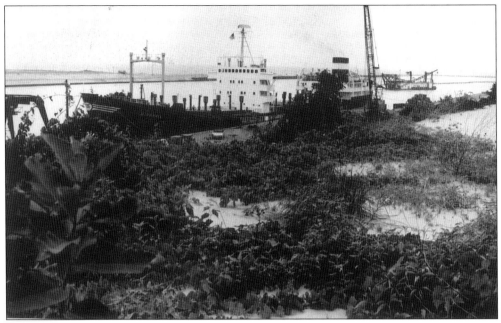

Water transportation has played a key role in the settling and industrial growth of Portage Township. It began with the birch-bark canoes of the Native Americans who inhabited this region and continues today with the giant sea-worthy vessels that come to the Port of Indiana.

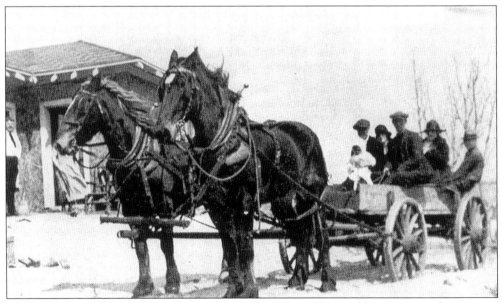

As recent as 90 years ago, horse-drawn vehicles brought settlers and businesses to this area.

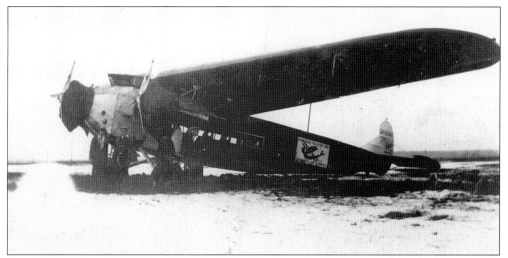

In January 1935, this Ford Tri-Motor Air Transport used the local landing field located at Airport Road and U.S. Highway 6.

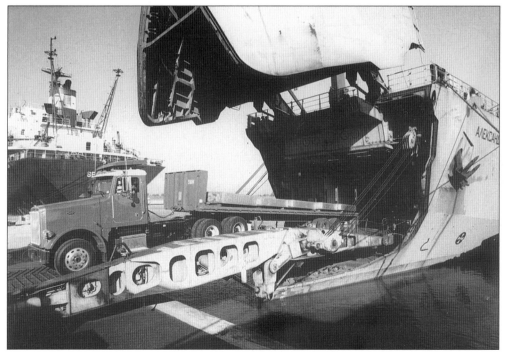

The bustling Port of Indiana witnesses the unloading of ships from all over the world. Big trucks like these are among the vehicles used.

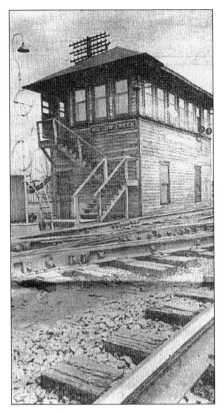

The Willow Creek Crossing witnessed some of the major events in railroad history. This famous switch tower handled the last of the steam engines and the first of the diesels. It was even the site of the brief power struggle between the B & O Railroad and the Michigan Central Railroad. Government militia had to be brought in to settle the dispute.

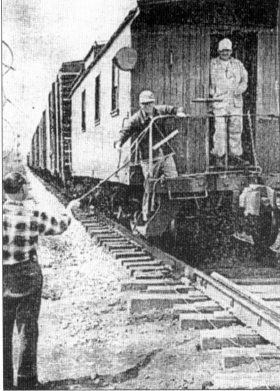

The freight conductor would receive his operating orders off a stick as the train rolled by. In the early years, orders were relayed by telegraph. Later replaced by the telephone, today on-board computers not only take the orders but even set the routes. The caboose has also disappeared, but some have found homes in railroad museums and a few have even been converted to cabins for vacationers.

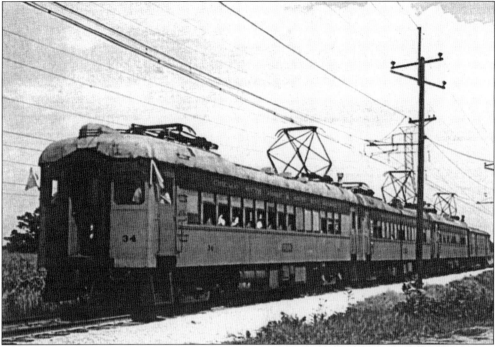

This was truly "The Little Engine That Could" better known as the Chicago South Shore and South Bend Railway Company. The train still runs today with longer, new-style coaches.

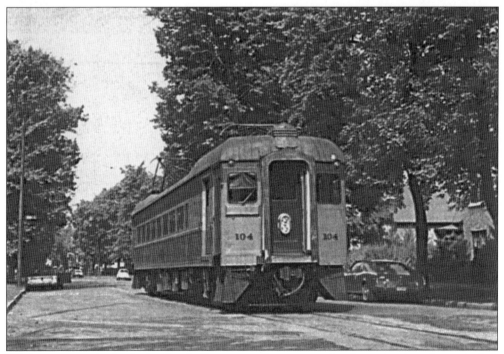

While most people think the South Shore runs along city and industrial rights of way, it does go through residential areas in Michigan City and South Bend.

The Willow Creek Switch House was being operated here by George Clarke. The big levers controlled switches down below so the trains were routed properly to their destination points.

The Dune Park train depot was north of the tracks on Highway 12. The New York Central, Pennsylvania, B & O, and the C & O all had a right of way past the station.

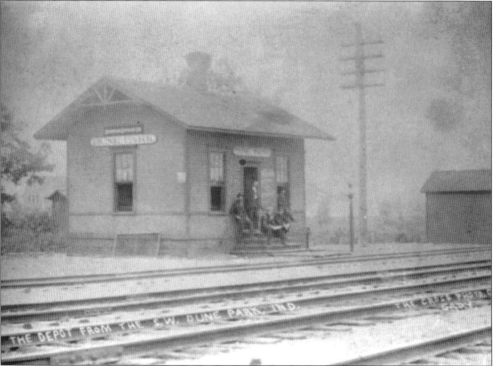

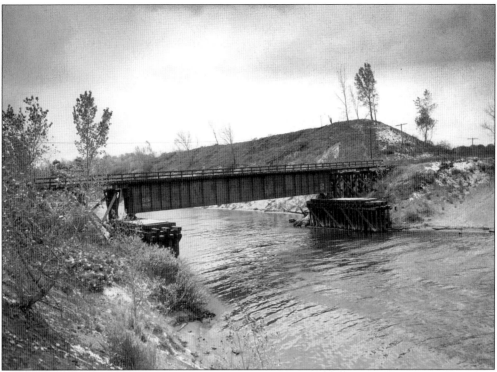

Steel rails, steel wheels, and steel bridges like this one brought the industry from the east and the west to the Lake Michigan shores.

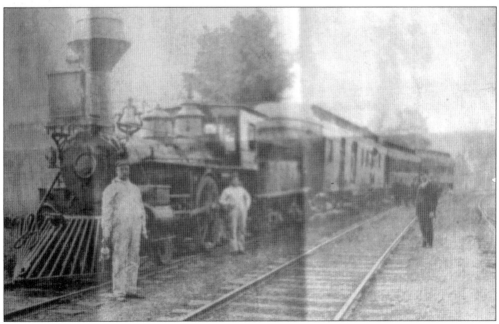

The Michigan Central Railway in the mid-1800s still sported a shovel on the front of the steam engine. It was commonly known as a "Cow Catcher" since its purpose was to persuade cattle off the tracks.

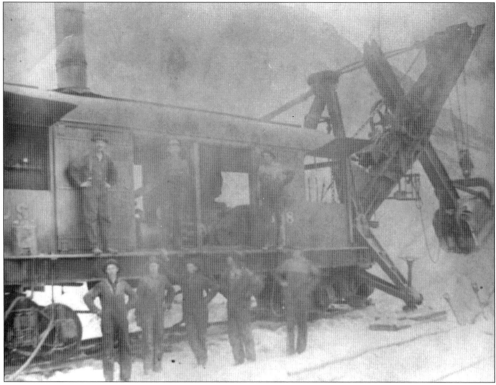

Railroad power shovels were used to mine sand that was used in the construction of railroads. The Crisman Sand Company was owned by the Nicholson family.

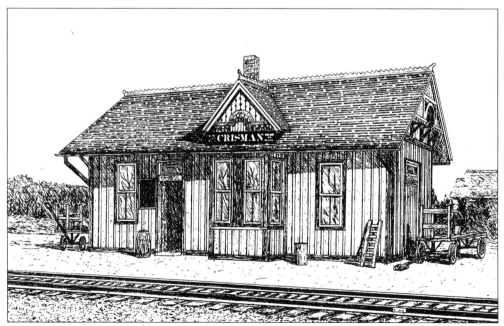

R. Ramsey Smith's drawing shows the old Crisman Station, which was located at the junction of Crisman Road and the old Michigan Central tracks. Those tracks are now used by CSX.

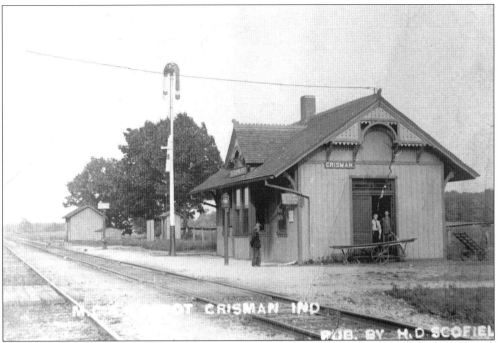

Notice the signal tower just to the left of the Crisman Station. The signals would let engineers know if they needed to stop to pick up mail or passengers.

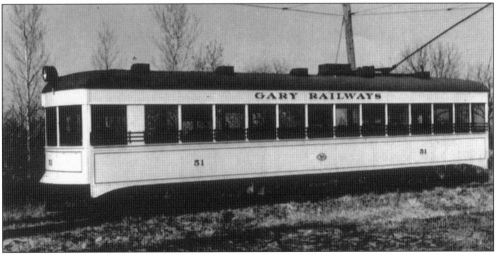

This is the Garyton Loop Railway in 1940. The Gary Railway Company operated streetcars from Gary to Lowell going south, and from Gary to LaPorte going east. It provided service to East Gary (Lake Station), Garyton, Crisman, McCool, and Valparaiso. Tickets only cost 8¢, but a book of 14 tickets was just $1.

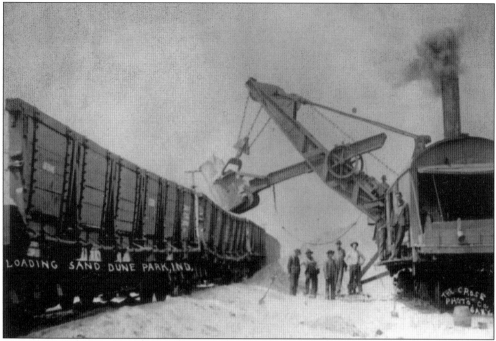

This Railroad Power Shovel is removing sand from Dune Park. The mining of sand opened the dunes lakeshore to allow U.S. Steel, Bethlehem Steel, and National Steel to build their companies. The sand was also used in the in the construction of I-94 and the Indiana Toll Road.

A Gary Railways Funeral Car reaches it final destination in this 1915 photo. A similar car carrying the body of President Abraham Lincoln stopped here at the Willow Creek Crossing on its way to Illinois.

The South Shore Railway ushered in a new era for Portage Township and opened the area to new business.

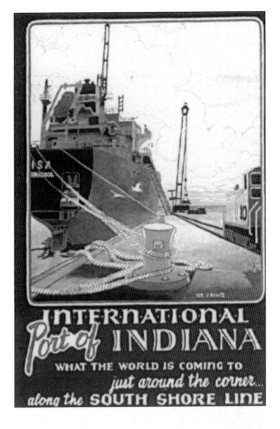

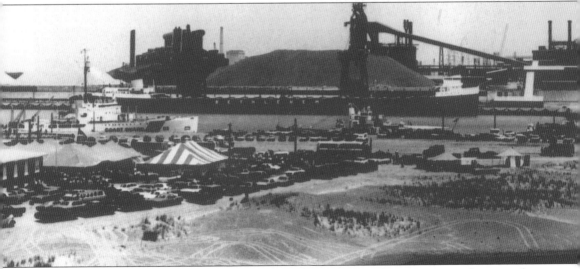

The Port of Indiana opened in 1970 and was the occasion of a major open house and celebration. Lapel pins were given to everyone in attendance. A Polish ship was the first ship to use the port. Since they did not have presents for all the dignitaries, they broke open cases of Polish beer instead.

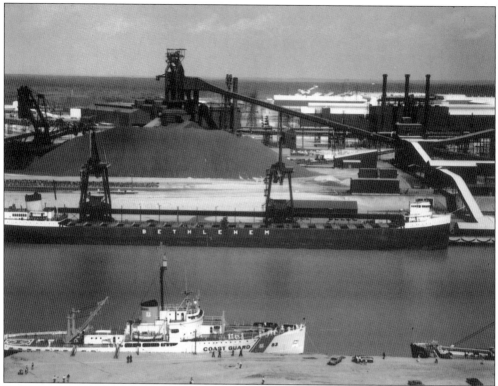

Bethlehem Steel Corporation is among the area's largest employers. In the forefront is the Coke plant with the rolling mills and blast furnaces in the background. Also shown is one of the many ships in the Bethlehem fleet.

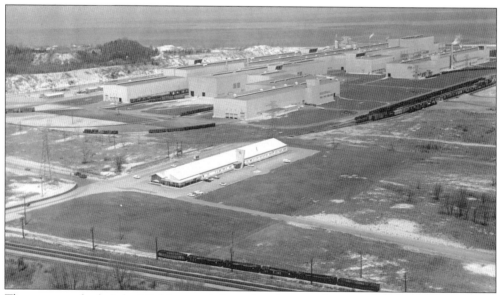

The access to both Lake Michigan and the railroads was a factor in bringing Midwest Steel Corporation to Portage, shown here in 1972. Rail cars moved coils, flats, shapes, bar, and slab steel all across the country.

Five

EDUCATION

In the early years following the establishment of Portage Township, formal education did not exist. Young men and women were literally "home schooled" by fathers and mothers. The boys learned hunting for meat and furs, making tools from rocks and trees, and building homes for shelter and barns for the animals. The girls worked inside the house learning to cook, sew, quilt, and preserve food for the winters. Conditions were still rather primitive, and survival was a daily occupation.

As the flow of people moved westward, the early pioneers were joined by all sorts of adventurers seeking new lives and livelihoods. Among those were educated individuals who offered instruction to settlers' children in return for pay, a place to stay, or a roof over their heads.

It was not until the latter part of the 1800s that several one-room schoolhouses were established. Sometimes these were simply homes that were used for classes. Portage Township did not have its first high school graduate until 1895, a class of one. The first formal commencement, with a class of eight, was held the next year at the McCool Methodist Church. Students came from Crisman, Garyton, and McCool. The township's first high school and multi-classroom elementary schools were built on the corner of Crisman Road and Portage Avenue. They were connected by an underground corridor. Crisman High School remained in use until the late 1950s when a new combined junior/senior high school was constructed at the corner of Central Avenue and Willowcreek Road and renamed Portage High School. The original Crisman High School and Elementary School are still standing but they are both empty. They still evoke fond memories and "stories" among those who went to school there, and the gym was witness to the township's athletic championships in the 1940s. Perhaps one day they will be resurrected with some new tenants.

As the population boomed in the 1960s and 70s, the Portage High School building underwent a number of expansions to accommodate the growing enrollment and modern curriculum. Vocational classrooms, auto shops, a print shop, and new home economics rooms were among the additions. In 1965, a new junior high for grades seven and eight, Aylesworth Middle School, was built on Central Avenue next to the high school, and elementary children who would attend the new South Haven Elementary School occupied the vacated classes for a while.

From the early 1960s until 1979, the school district grew from four schools to eleven! When this growth spurt was over, the Portage Township Schools boasted the largest school district in the county and one of the largest high schools in the state. Included were a high school complex on Highway 6 and Airport Road for grades 9-12, two middle schools for grades 6-8, and eight elementary schools for grades K-5. The combined enrollment was close to 7,000 students.

Since that time, the school board has added a new central administrative office, new bus sheds with a vocational classroom for diesel mechanics, a library services center, a food services center, a maintenance and repair facility, and a community health clinic.

The Portage Township Schools consistently rank among the top 10 largest districts in Indiana. Besides the traditional K-12 educational program, students have access to several vocational programs in other Porter County schools, special needs classes for students being mainstreamed, and an Adult Education Program for adults and students who no longer attend the regular classes.

From its very humble beginnings, the schools have grown to become Portage Township's third largest business. Now that the number of students has remained fairly constant, the school board can earmark funds for technical and mechanical improvements that will keep the schools on a competitive level. When completed, every classroom in the Portage schools will have computer access and air conditioning.

In addition to their educational activities, the schools and their facilities are used by numerous civic and private organizations for a wide variety of programs. The YMCA offers swim and exercise classes in the school's pool, and Community Concerts utilize the high school's auditoriums. The athletic fields and parking lots have been home to the American Cancer Society's Relay for Life, the police department's safety and driving schools, and the Portage Park Department's car shows and festivals. Even the cafeterias have been sites for pancake breakfasts and chili suppers, put on by the different service organizations. The schools are also open to adults who want to come inside to walk each day for exercise, so even the halls have become useful. All of this typifies the close working relationship that exists between the schools and the citizens.

The schools have become an essential and integral part of the educational, social, and charitable fabric of Portage Township.

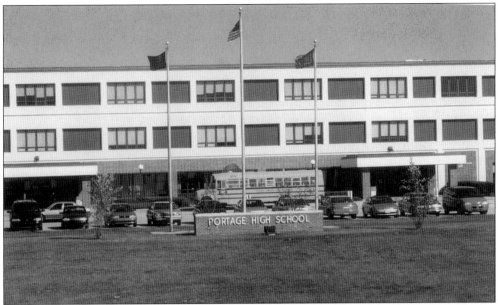

The current Portage High School was built in 1980 on U.S. Highway 6 at Airport Road. It was the largest high school in the county in size and enrollment.

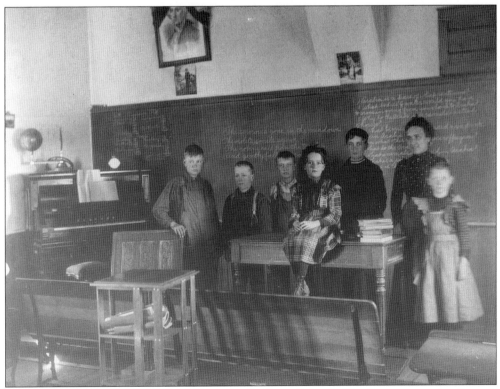

Dora Schrock was a teacher in 1898 at the Robbins School. The "one-room schoolhouse" accommodated all the grades and taught all the subjects, even music, which explains the presence of the piano. Teachers had to know it all.

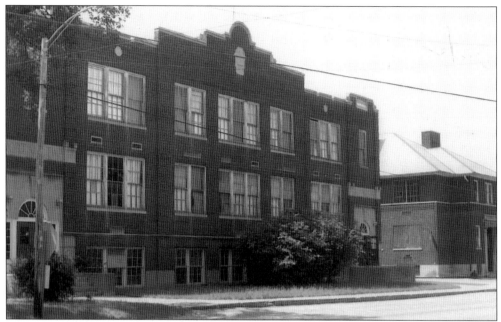

Built in 1928, Crisman High School still stands but no longer reverberates with the sounds of students getting an education. In recent times, it has been used as an auxiliary building by the Portage Township Schools before being sold to a series of owners. It is still waiting for a new lease on life.

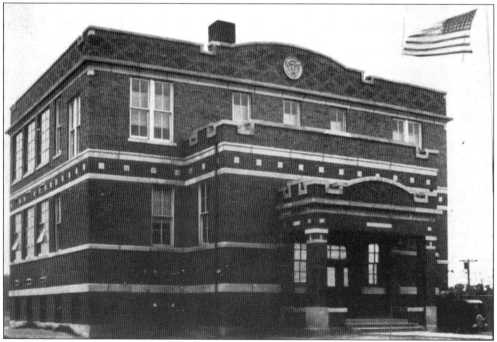

The Garyton School, built in 1931, stands on Central Avenue and is still in use. The office and classrooms now are the home of the Portage Adult Education Center and Adult High School. The cafeteria, kitchen, and gym are now headquarters for the Portage Food Pantry.

The bell tower on top of McCool School would signal to students and parents that school was about to begin or end. Constructed in 1931, it is now a residence at the corner of McCool Road and Lenburg Road.

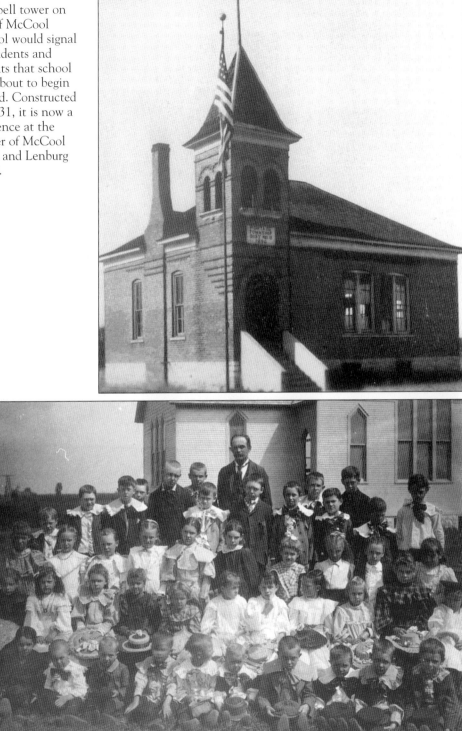

School clothes often give a vivid reminder of how times and fashions change. That is certainly true of this Class I at McCool School.

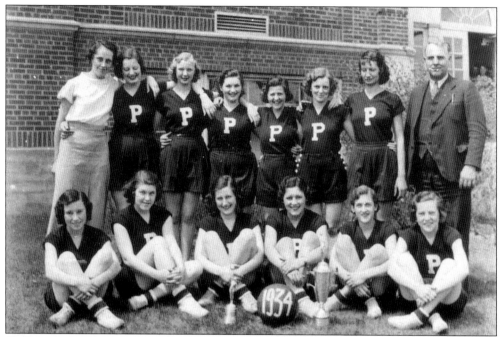

Girl's basketball became very popular in the 1920s and 30s at Crisman High School. Shown here is the team from 1934. Standing far right is Leroy C. Hoff, principal. Upon retiring, Mr. Hoff moved to Missouri with his cow and piano.

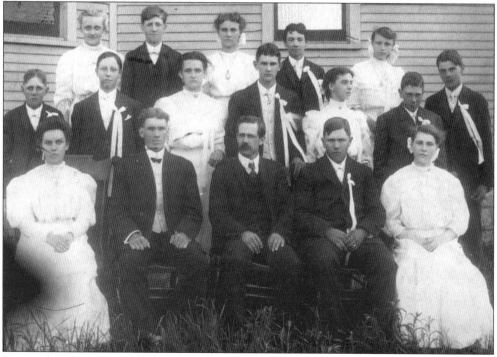

Principal and teacher William Briggs (center) sits with his other teachers with the Class of 1906 standing behind them. Briggs was the first principal at the school.

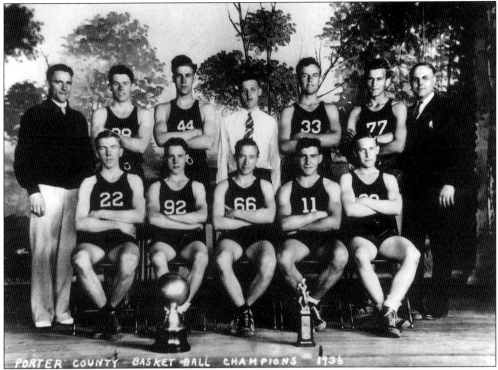

In 1936, the Crisman High School boys were the Porter County Basketball Champions.

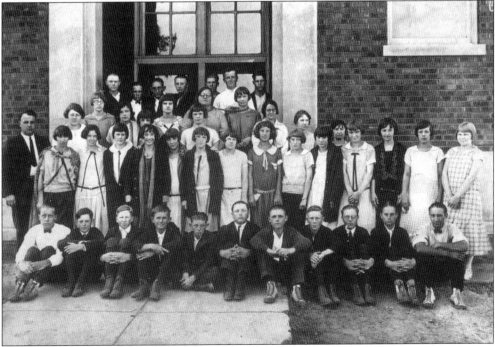

We proudly present the Crisman graduating class of 1925. It was a special day and they donned their fashionable dress for the occasion.

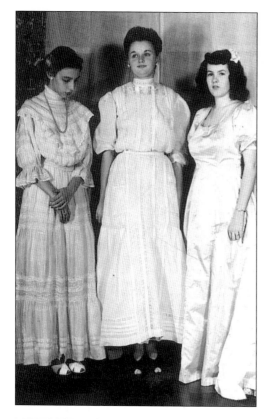

The Bridal Fashion Show (*c.* 1944) featured dresses from some of the teachers. The models were Mary Jane Moatz, Joan Carpenter, and Jean Dunzinger.

The Peak School once sat on this site on Swanson Road.

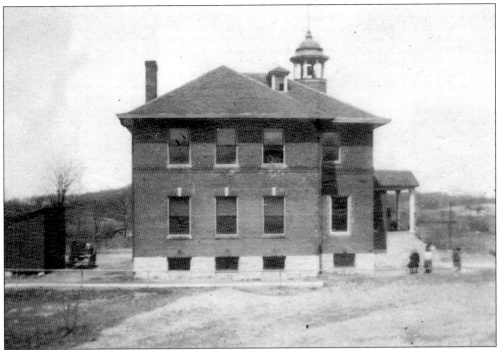

The original Crisman High School served as a grade school and a high school.

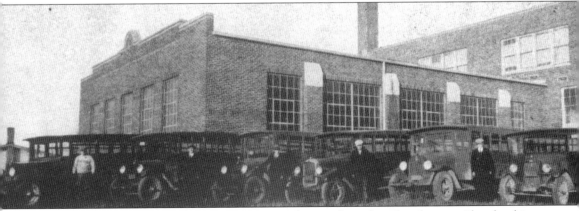

School busses have also undergone some major changes from these lined up outside school in 1929 ready to take children home.

Here are some examples of the "preppy" look from the 1930s. It was colorful dresses for the girls and ties for the boys.

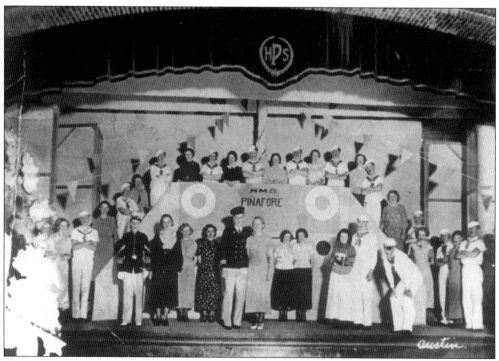

The Portage High School Theater Group staged this 1934 performance of *H.M.S. Pinafore*. Not quite a Broadway production, but it captures the early interest in the arts.

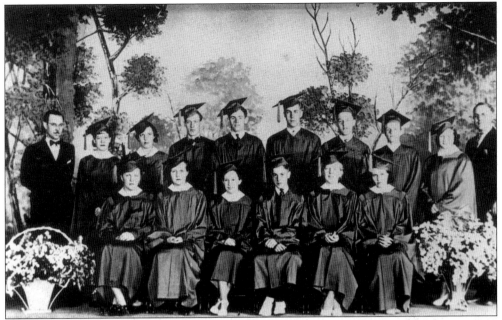

The cap and gown are symbolic of high school graduation as can be seen in the photograph of the Class of 1936.

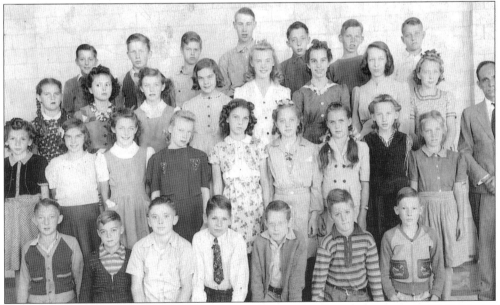

Garyton Grade School's 6th-grade class shows-off the styles that were current in 1942. Notice the hairstyles, especially for the girls. Boys are wearing pullovers and girls' dresses are colorful and patterned.

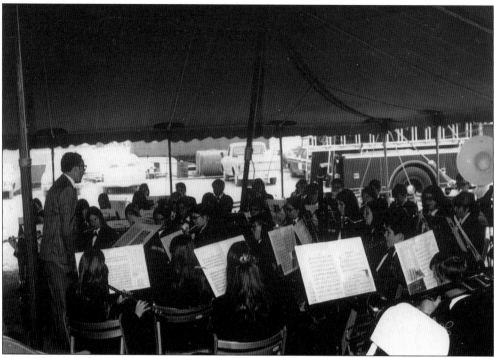

The Portage High School Band and Orchestra were a vital part of the curriculum.

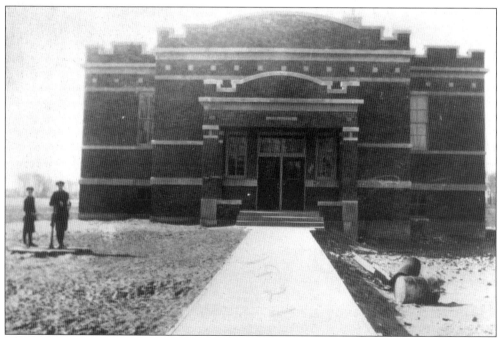

This is Garyton School as it looked in 1921. The imposing façade is distinctive of that period in school construction.

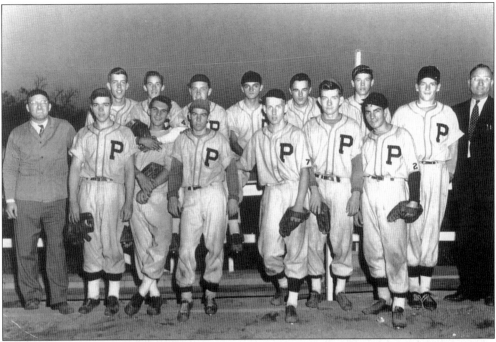

In 1950, the Portage High School's baseball team was crowned champions of the Calumet Conference and Porter County.

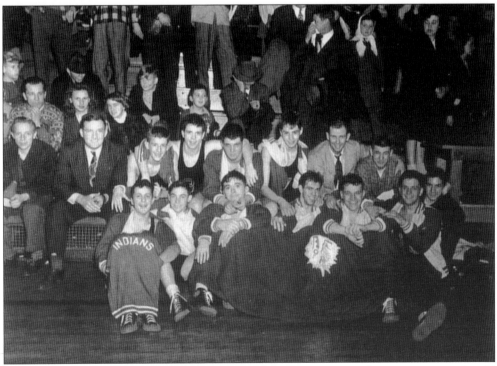

Portage High School's 1948 basketball team posed for this picture in the gymnasium at the old Crisman High School. Only a part of the wood floor still exists today.

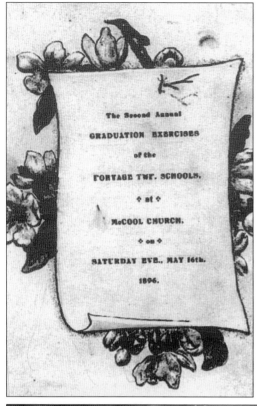

The second graduating class had this program cover in 1896. The ceremony was held at McCool Church. The graduates were Celia Recktenwall—salutatorian, Anna Lenburg, Amanda Malmstone, Mary Hommes, Amelia Lenburg, Ross Crisman, August Malmstone, and Carl Johnson.

Emma Crisman and Mr. C. Sharp were two of Portage's early teachers.

Nancy Clark, the current head librarian at the Portage Public Library, receives an award for her work in the community.

Dr. Donald Bivens was a popular long-term superintendent of the Portage Township Schools.

The high school band military-style uniforms show the war's influence in the 1940s.

Teacher's pets or little rascals? Mrs. Rose (lindquist) Garrison had the same students all day long for math, English, writing, reading, music, and history.

Six

RECREATION

Today, Portage sits in a haven of tourism with Dunes State Park and the National Lakeshore to the east. Portage has West Beach, an extension of the Dunes National Lakeshore, as well as the Marshline Walking Trail, which lies between U.S. 12 and Stagecoach Road. In just a short distance, people will pass through forest, prairie grassland, wetland marsh, and culminate with a climb to the top of a large sand dune, which affords a panoramic view of Lake Michigan, from Chicago in the west to Michigan City in the east. The Dunes State Park offers camping, picnic areas, and a large public bathing beach.

Hundreds of thousands of people come to see a true wonder of the world—the Great Sand Dunes of Lake Michigan. The golden sand of the dunes offers warmth in summer, but the dunes become a barren landscape in winter with towering blocks of ice.

Both Dunes State Park and West Beach offer great views, and if one is lucky, one may witness herds of deer, various species of birds, and other wildlife. Boating and fishing are prevalent on the lake. Lake trout, small and large-mouth bass, catfish, perch, and walleye pike are just a few of the many species of fish. Lake Yellow Perch are only found in Lake Michigan and nearby lakes. The perch are a real delicacy, but they share the spotlight with the walleye pike, another great eating fish.

The Portage Marina, plus the increase of marinas from Chicago to western Michigan, allows boaters of all kinds to set afloat in the waters of Lake Michigan. From Memorial Day weekend to Labor Day, the lake comes alive with colorful boats, swimmers, and sun-seekers of all kinds.

The Prairie Duneland Trail is a hiking/biking trail that runs from Chesterton to Hobart on the old E.J. & E. Railroad right of way. The new Ironhorse Trail on the former old Michigan Central right of way will be added with construction scheduled for 2003. Both of these are part of the nationwide Rails to Trails project, which converts abandoned rail lines into recreational paths. One day they will stretch from coast to coast.

Portage also enjoys a diverse park system. Woodland Park is the nucleus and the home of the park's offices. Woodland offers walking trails, a new skateboarding venue, picnic shelters, baseball diamonds, tennis courts, and a banquet facility. The park has been the site for numerous concerts, festivals, and other community-wide activities.

Imagination Glen is located along Salt Creek at McCool Road and Portage Avenue. It is the

home for softball and soccer fields. A BMX track that holds major competitions is located between the east side of Salt Creek and Route 249. The BMX events draw competitors from all over the country.

Another facility great for banquets, weddings, and even small conventions is the Portage Yacht Club. Originally the Midwest Steel Supervisors Club, it was purchased with the intent of becoming the site of a city golf course. Unforeseen obstacles have put the project on indefinite hold.

Countryside Park along U.S. 6 is also home to the Portage Township Historical Society. This turn-of-the-century farmhouse and barn will soon be joined by a new exhibition hall. The farmhouse is being restored as a period home, and the new museum (under construction) will be home to Indian artifacts, a 1929 American LaFrance fire truck, topographical maps, agricultural tools and machinery, plus personal memorabilia from early settlers.

Countryside Park also has additional features. There is a fishing pond stocked with catfish, bluegill, crappie, and bass. A snowboard/toboggan hill is popular during the winter months, and the Prairie Duneland Trail passes through the front entrance to the park. The annual Historical Society Festival and a yard sale are held here as well.

Adjoining South Haven on 700 N is Haven Hollow Park. It boasts several excellent baseball and softball diamonds as well as a playground for little kids and picnic shelters, which were erected by the South Haven Lions Club. A number of trails lead down to the banks of Salt Creek.

In addition to the parks mentioned, the city has several neighborhood parks, which have swing sets and picnic areas. Other recreational and leisure-time entertainment venues are available. Robbinhurst Golf Course provides fun in the sun and 18 holes for frustrated golf-pro "wannabees." If it's indoor sports, then bowling at Camelot Lanes may be the answer. R-Way Skate Center caters to all ages with its classes and open skating. Several of the local lounges in town also host horseshoe and dart tournaments on a regular basis.

During the summer months, a number of township-wide festivals and events are held. Two of the most enduring are the Historical Society Festival held the last Saturday of June at Countryside Park and the Portage American Legion Post 260 Picnic in August. Among other events are arts and crafts shows, the Steelwheels Jamboree, Relay for Life, and Sunday evening concerts at Gilbert Park on Willowcreek arranged by Community Concerts.

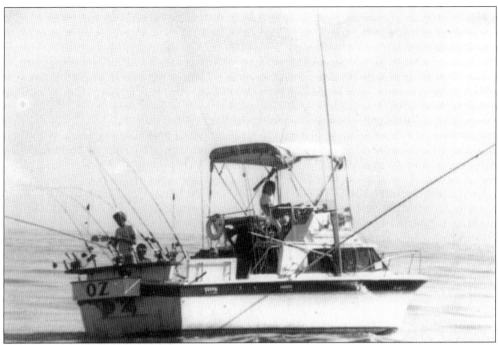

The Great Lakes of the Midwest are the only home for Lake Perch. Both sportsmen and commercial fisheries have impacted their numbers.

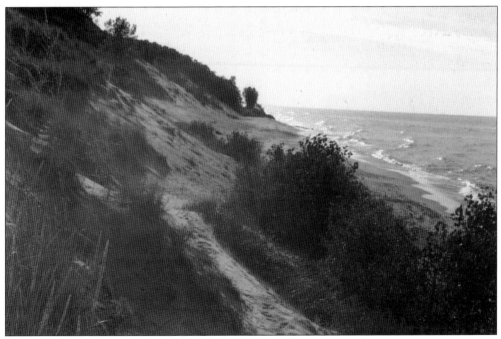

The sand dunes at the southern tip of Lake Michigan have attracted tourists, summer visitors, and business interests for years. The stretch of dunes through Portage Township is home to Ogden Dunes, Bethlehem and National Steel Mills, and public beaches.

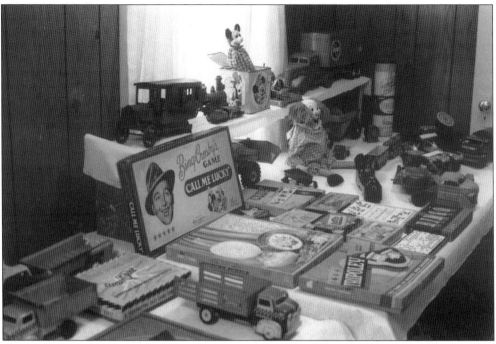

Old toys are among the many items being preserved in the Portage Historical Museum located in Countryside Park on Highway 6. The museum is open from March to December each year.

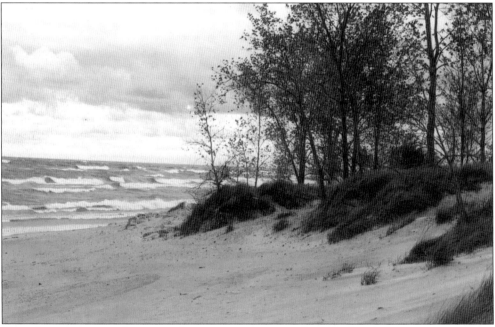

Blue sky, white-capped waters, dune grasses, trees, and sandy beaches come together in harmony on the Portage shores of Lake Michigan in this photo taken by Verlaine Wright in 2000.

This deserted Nike missile site on 700 N at Airport Road is a grim reminder of the Cold War and the threats posed to America. Although the program was short-lived, this facility has become a recreational paint ball camp.

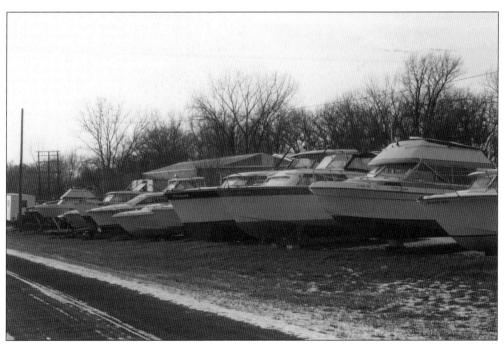

Pleasure craft and fishing boats abound on Lake Michigan during the summer. This industry alone has grown an estimated 500 percent since the 1980s.

"Gentlemen, Start Your Engines!" Robbins Golf Course is a popular destination for several civic groups who use golf-outings and tournaments as fundraisers.

The Portage High School Chorales have delighted audiences for years.

This abandoned lakefront home is located on property that became part of the Indiana Dunes State Park and Indiana Dunes National Lakeshore Park. The Dunes was known for its summer homes. Some homes were purchased with a lease-back option, but not this one.

The Portage Carnival was set up in the vacant area behind McDonald's on Central Avenue in 1987. With rides and games, it attracted large crowds.

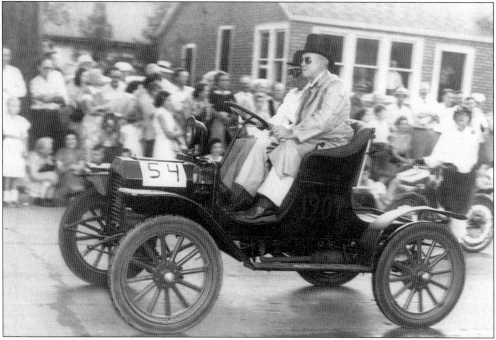

George Samuelson is driving his 1907 Reo during a Portage 4th of July parade with Chester Robbins as his passenger. There was a Reo dealership in McCool, but Reo discontinued manufacturing cars and became better known for its trucks and fire engines.

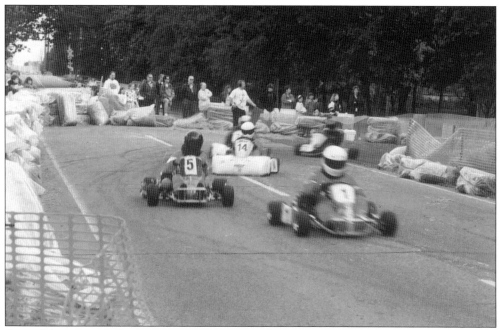

One of the summer's biggest events was an annual Portage Grand Prix Go-Kart Racing. Go-Karters came from all over the country to participate. Due to problems with financial support, it is no longer held.

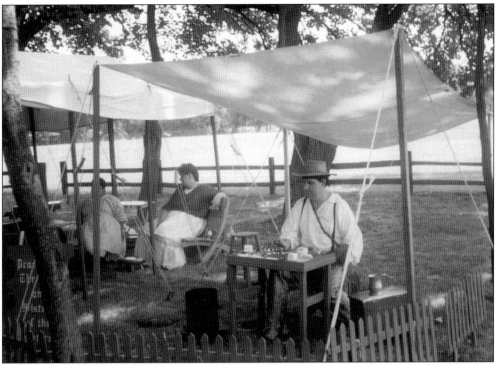

The last Saturday of June is the date for the annual Portage Historical Society Picnic. Open to all the residents of Portage Township, the proceeds are used for the upkeep and development of the society's museum and collection. Period dress is encouraged.

The South Haven Lions, with their signature Hi-Strikers, are set up at the Portage Fest behind McDonald's on Central Avenue.

Antique and classic cars generate tremendous interest from young and old alike. The Winamac Car Club was among the participants at Countryside Park in June. Indiana's love affair with cars is part of our history.

This is a picture of the 4th of July Parade in 1958, looking west from Gilbert's Service Station on Central Avenue. This was the area known as Garyton.

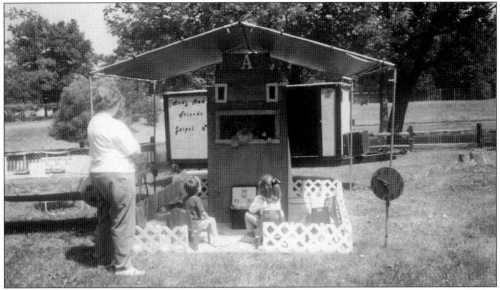

A puppet show at Countryside Park holds the rapt attention of these kids.

Among the entertainers at the Historical Society Picnic in 1999 was the Bonner Senior Center Singers. The Bonner Center is operated by the township trustee's office.

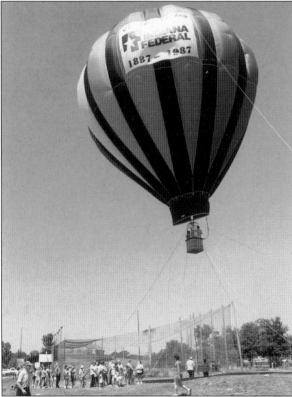

Portage's best-kept secret is the Portage Historical Society Museum and their annual festival. The museum is presently housed in this 1910 farm home at Countryside Park. A new museum will be built next to it for housing area artifacts, and the farmhouse will be returned to a 1910 period home.

A hot air balloon hovers over the old batting cages behind the Portage Mall. Removed in the 1990s, the land is slated for the new Main Street Development Project.

In 1948, Hazel Grey was soaking up the rays at the beach. What a way to spend the day!

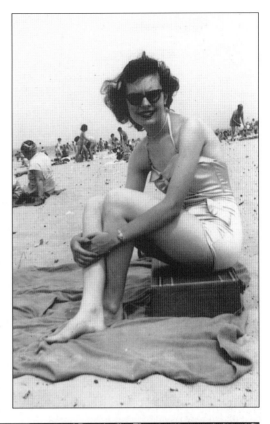

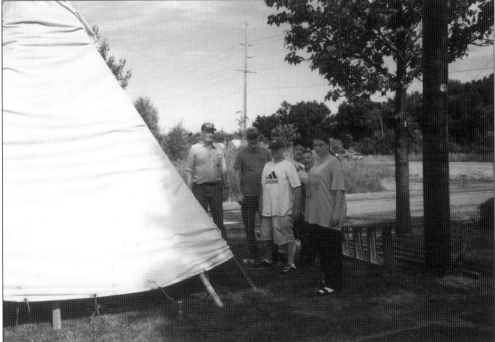

These Boy Scouts spent two nights in this Indian tepee they had built.

Three members of the all-girl singing group "Wolfgang," sing the "Star-Spangled Banner" at the Historical Society Festival in 2001.

3rd Annual

Portage Grand Prix Jamboree

Big cars, little cars,

Junior Misses too

Lots of fun

Is planned for you.

Friday, Saturday and Sunday

June 26, 27 & 28, 1981

SCHEDULE OF EVENTS REVERSE SIDE

Co-Sponsored by
Portage Chamber of Commerce

City of Portage

N.W. Indiana Sports Car Club of America

This flyer promoted the Portage Grand Prix Jamboree. Before the influx of too many businesses along Central Avenue, sprint cars would race through the Town and Country parking lot and out onto Central Avenue. A growing concern for safety resulted in the race being moved to Woodland Park before it was discontinued entirely.

Some 18,000 people came to the Dune Park Ski Jump to see the 2nd Annual Amateur Ski Tournament. Many rode by South Shore to the Wickliffe Station, now known as the Ogden Dunes Station.

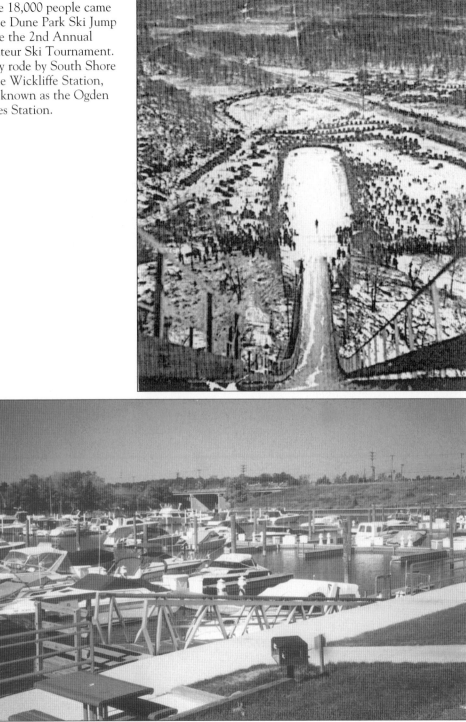

The Portage Marina was built in 1997 and is considering expansion in the near future. The marina is 100-percent full with a waiting list for slips. Owned by the City of Portage, the development of the mooring received close scrutiny.

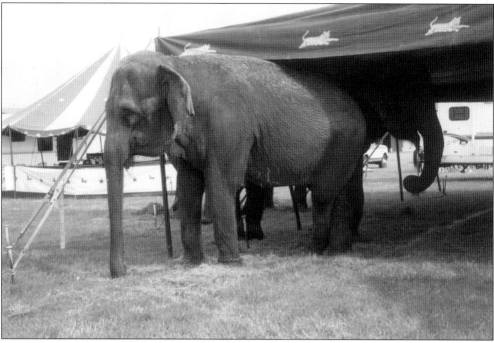

Once a year, the traveling circus comes to Portage with all the traditional trappings, including playful pachyderms.

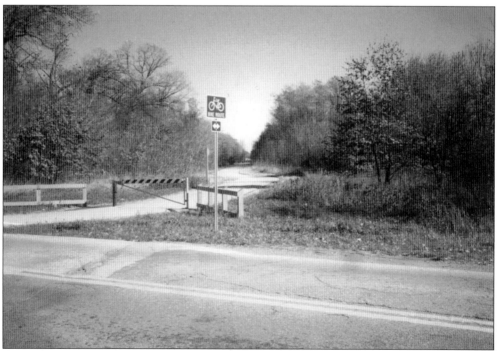

The first "Rails to Trails" project completed follows the old E.J. & E. Railroad route. It starts on the west side of Chesterton and goes all the way to Hobart. Hikers, bikers, and animal lovers make full use of this scenic route.

Seven

BUSINESS

KEY TO PORTAGE'S
CONTINUED GROWTH

Portage has come a long way from general stores, railroad depots, and farmhouses. Today, it is a growing center of industry and retail outlets. Although Portage has experienced healthy, steady growth in recent years, it was not always the case.

George Pullman, the railroad manufacturing mogul, wanted to locate a factory south of Central and west of Willowdale Road. A list of demands was put on Pullman by the political and civic leaders of the time. Pullman felt they were too extreme and decided to look elsewhere. He settled for a site just west of I-94 and 106th Street in Chicago. This area is still known as Pullman.

J.P. Morgan, the famous banker from New York, also looked at this area to develop. Morgan ultimately considered it too primitive and too removed from Chicago. Another famous name from that same period, V.K. Vanderbilt, platted a subdivision along U.S. 12 in the northeast quadrant of the township. Unfortunately, the stock market crash of 1929 and the ensuing Great Depression put an end to those plans.

John Cooley was another man with big ideas for Portage Township. He saw Burns Canal as a major waterway and transportation source. He also envisioned an electric trolley system, which would run from the lakeshore to U.S. 6 down Willowcreek Road. Due to some stumbling blocks and more imagination than money, Cooley's dream remained just that. He did, however, build Cooley's Subdivisions 1910 and 1920 on Brown Street. The Cooley Station was a stop on the Gary Transit Electric Trolley Line.

Local myths and legends always make for good stories, and Portage Township is not without its own. Abraham Lincoln's funeral train passed through here on its way to Chicago. Supposedly, two men brought lumber, tools, and other supplies to a location in northeast Portage Township where they were going to prepare a make-shift grave intended for Lincoln's body. The two men were going to rob his grave in Springfield, Illinois, and hide the body here, intending to hold it for ransom. The plot never unfolded as the two men got "likkered up" in Springfield the night before they planned to rob the grave. They were overheard talking about their dastardly deed. The sheriff took them into custody and they confessed. Fact? Legend? While unconfirmed, it's a good story.

Some unusual businesses have operated in Portage Township over the years. At one time

Portage had two brick factories: One was in the West Beach area east of County Line Road, and the other was in the southwest corner of the township at County Line Road and State Road 130. Early in the 1900s, a prosperous mink farm was located where Engel's Funeral Home and adjacent businesses now operate. The Portage Mall was one of the first malls in the area. In the 1960s and 70s, it thrived with a variety of stores, shops, professional offices, and restaurants. The over 40 mall buildings were owned by about 22 different owners. As the business center began moving down Willowcreek Road and along U.S. 6, the mall started deteriorating. Several attempts were made to attract new businesses and shoppers, but they were not very successful. However, with the advent of the Downtown Revitalization Project's Phase I in 2003, the mall once more faces a promising future. When it is finished, some of the old buildings will be gone, others refurbished, and new ones erected. The proposed centerpiece will be a new Portage City Hall at the north end.

The city and township continue to grow in population. In fact, the unincorporated areas of the township have a greater population than any of the others in the county. South Haven and South Haven Acres account for almost 10,000 people. Started in the 1960s by builder Paul Saylor, South Haven is a one square mile subdivision of moderately-priced homes designed for the influx of workers who came to this area when Bethlehem Steel built its new mill on the shores of Lake Michigan. South Haven Acres to the immediate south and west of South Haven is approximately half the size. Two of Portage Township's eight elementary schools are located in South Haven itself, and one is named after Paul Saylor.

Business opportunities are available in virtually every part of the township. With the widening of U.S. 6, retail growth in the southern half will continue to expand along its entire length through Portage Township, from County Line Road on the west to Route 149 on the east. In the northern part, the new Ameriplex business park at the I-94 exit offers prime locations for industrial growth and business ventures. Additional expansion continues at the Port of Indiana, too.

While the steel industries are experiencing major changes from foreign competition, they continue to be a vital factor in the area's economy. Their difficulties, though, have caused a big focus on diversification as a means of re-establishing economic health.

Portage Township is a far different place than it was when first settled and platted in the 1830s. If any of the early settlers could see it today, they would hardly recognize it. But there are still vestiges from those days that can be found and treasured as part of the area's history and legacy. In many ways, Portage Township still has its feet firmly rooted in its past and holds on to its small town image; at the same time, it is refurbishing itself and building a modern community for the 21st century.

Rubino's Music was on the west end of the Portage Mall.

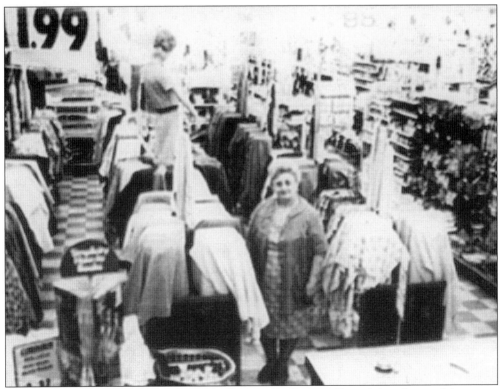

The Ben Franklin Store in the Portage Mall seemed to have it all until the advent of the super-stores like K-Mart and Wal-Mart. Mrs. Brevak is pictured here in the yard goods department.

San Bonn's Hallmark was a long-time fixture in the Portage Commons. Recently closed, a hobby shop has moved into the building.

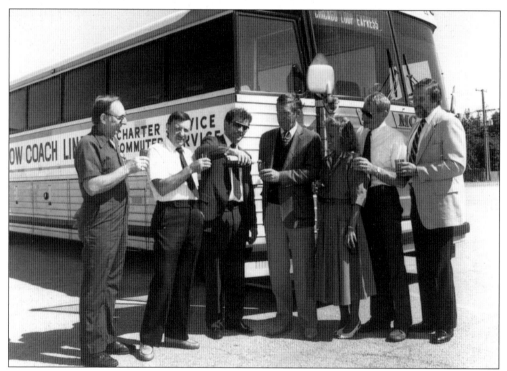

After being moved a number of times to temporary sites, TriState Coach Lines and the City of Portage entered a long-term agreement. The city converted the old post office site into a passenger-parking and bus-loading facility with shelter. With its merger with United Limo, the bus company is now Coach USA. Busses service both Midway and O'Hare Airports with hourly pick-ups and deliveries.

The Coca-Cola plant, built in the 1980s, was the first in the industrial park between Highway 20 and I-94 and has been a valuable addition to the business community.

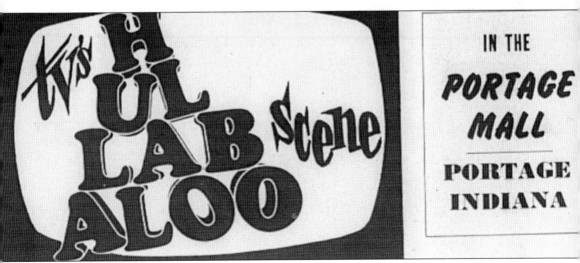

This bumper sticker advertises the teen and young adult dance club called "Hullabaloo." Located on the east side of the Portage Mall in the last building, it was franchised after a popular NBC music program in the 1960s. The Hullabaloo featured area rock bands and big name groups such as the Turtles, the Animals, the Hollies, the Who, The Association, John Fred and the Playboy Band, Blues Magoo's, and Tommy James and the Shondells. The club opened in 1967 and closed in the early 1970s.

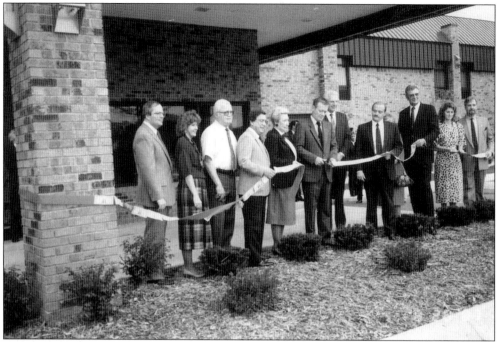

The motel industry has discovered Portage, and Portage now boasts to having the most motels in the county. The ribbon cutting at Lee's Inn (now Comfort Inn) across from the Indiana Tollroad entrance helped spark the growth.

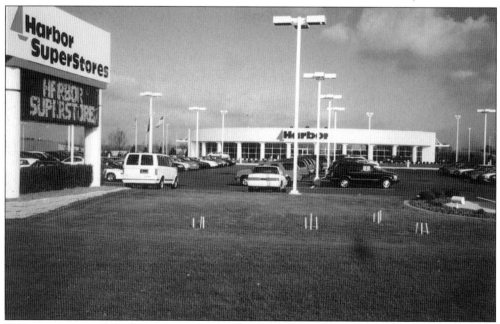

Harbor Superstore was the first mega-auto dealer in Portage. Containing a full repair service area, it is situated next to the Super K-Mart on U.S. Highway 6. Another large auto dealership is proposed by Neilsens at the corner of Highway 6 and County Line Road.

New home construction and renovation of existing homes are in evidence all over the township and are expected to continue.

Another pressing need is affordable housing for the growing population. Apartments and condominiums are in big demand.

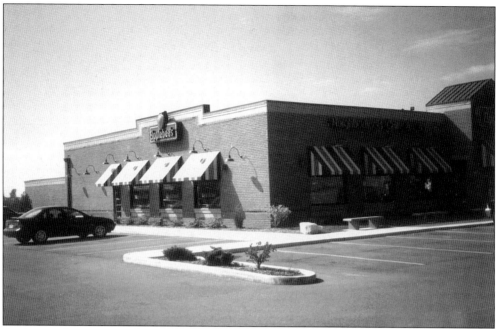

As the area has grown, so has the demand for more upscale restaurants. Applebee's on Highway 6 is one of the latest additions.

The Portage 9 Cinema on U.S. Highway 6 is the first multi-screen facility in the city. Completed in 1998, it shows all the current movie releases. It fills a void that existed for many years after the closing of the Jerry Lewis Cinema that was on Central Avenue.

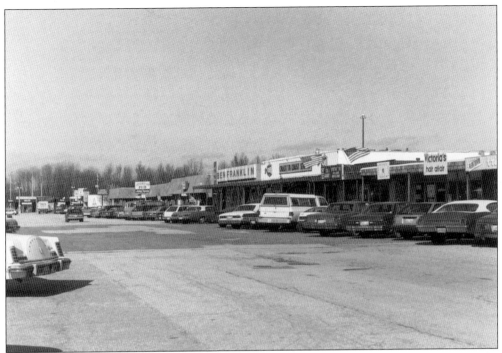

Ben Franklin, Coast to Coast Hardware, and Alan & David's Barber Shop were among the tenants on the east side of the Portage Mall in the 1970s.

The "new" Town & Country simply moved from one end of the Meadows Shopping Center to the other, but its enlarged size and new façade have ushered in a new revitalization of the entire "downtown" area.

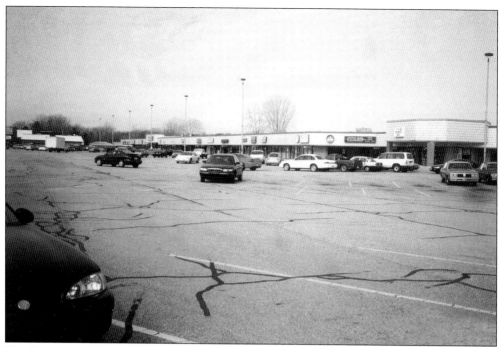

The Portage Commons Shopping Center at the corner of Willowcreek Road and Highway 6 led the expansion of businesses toward the south side of the city.

New retail spaces such as these will help attract much needed small businesses to the community.

Eight

THE EMERGENCE OF
PORTAGE AS A
MUNICIPAL FORCE

The city that would become Portage was a long time in developing. From 1834 to 1959, Portage Township had no municipal status. It was governed by the township trustees and justices of the peace. The county sheriff and volunteer firefighters provided the protection that was necessary for the residents. Throughout that period, the areas of Crisman, Garyton, and McCool remained the "cores" of the community, with Ogden Dunes to the northwest a primarily residential appendage. The only other major development in the township did not take place until the late 1950s when the subdivision known as South Haven was started.

In 1959, the entity now known as Portage officially became a town. That was the same year the Chicago White Sox won the World Series and the steel mills had their longest strike in history. The initial town limits incorporated Crisman, Garyton, McCool, and Ogden Dunes but did not extend to South Haven. Having achieved town status, Portage was governed by an elected Town Board, had to establish official fire and police departments, and was responsible for providing water and sanitation. The first "seat of government" was actually a small, frame, garage-like building on Central Avenue near Swanson Road that housed both the town board offices and the police department. It was known at the Municipal Building. A bit further west on the curve was the cinder-block home of the fire department. (When the fire department moved into new quarters, the JayCees used the building for their clubhouse and annual Halloween House of Horrors.) Those areas of Portage Township outside the town limits remained unincorporated and continued to receive services from the township and county. With its establishment and identification as a town, Portage began to prosper and expand.

Like many new towns, it was faced with incessant demands for new and improved services. The arrival of Bethlehem Steel brought an infusion of new residents and businesses, all of which placed new strains on every phase of the operations. Between 1959 and 1967 alone, the Portage Township Schools added a new middle school and five new elementary schools.

It was in 1967 that Portage joined Valparaiso to become Porter County's second city. With city status, Portage's governing bodies also changed again. Now a mayor and elected city councilmen would direct its operations. A new city hall was built at 6250 Central Avenue that also housed the fire department. The first mayor was Arthur Olsen who served one term from 1968 to 1972. He was followed by Robert Goin, the only Republican mayor, who held the office

for 12 years, though not consecutively. His first term was from 1972 to 1980. John Williams took over from 1980 to 1984, and Robert Goin came back for another term from 1984 to 1988. The city's fourth mayor was Sammie Maletta who had a 12-year run from 1988 to 2000. The present mayor, Douglas Olsen, was elected in 2000 and is the son of the first mayor.

The current Portage Fire Department now consists of three fire stations with fully trained fire fighters and paramedics ready to handle any emergencies. They also work in conjunction with the South Haven Fire Department when needed in the unincorporated areas of the township. A fire that destroyed the original Kelsey's Steakhouse on U.S. 6 prompted the department to obtain its first aerial ladder truck, and they have continued to maintain state of the art equipment since.

The Portage Police Department is located on Irving Street, next door to the Portage Library. The department boasts a SWAT team and a detective bureau plus a canine unit. Here's a little-known fact about the first dog. The only one available just understood Czech commands. As a result, the officer had to be trained in the dog's native tongue, so to speak. Like their counterparts in the fire department, the Portage Police maintain an exemplary roster of officers well trained in all aspects of law enforcement.

Unlike many older cities that formed around a single community, Portage has never had a recognized "downtown". While the intersection of Willowcreek and Central Avenue may constitute the "center" of town, businesses and industries can be found in virtually every area within the city limits. That issue is one that is currently being addressed by the city officials and planners. The widening of Willowcreek Road to U.S. 6 and the widening of U. S. 6 from County Line Road to Route 149, the revitalization of Central Avenue and the Portage Mall, and the creation of the Ameriplex industrial park are all part of that effort.

When completed, Portage will have put on a whole new look, attractive to new homes and new businesses. In 50 years, Portage has gone from being a small town to the largest city in the county.

Portage's newly renovated library has a complete children's section with room for activities in addition to an extensive reference area and a history room. Besides books, tapes and movies are also available for check out. The Friends of the Library operate a Used Book Store, and meeting rooms are open to public organizations. It is located next to the police station on Irving Street.

The new Portage Post Office on Willowcreek Road is a full-service facility with its own Stamp Collecting Store. It replaced the old post office on the corner of Irving and Central Avenue, which is now a parking lot for the Coach USA airport buses.

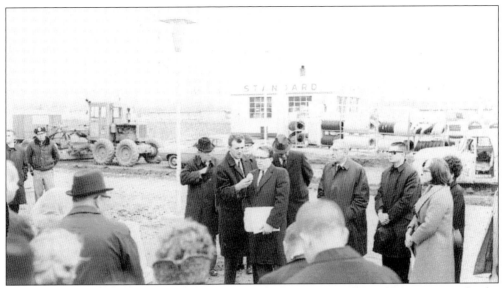

A major event for the newly-created City of Portage was the ground-breaking ceremony for the new city hall at 6250 Central Avenue.

A large oak tree used to stand to the right of the gate to Calvary Cemetery. The tree had to be removed in 1957, however, because it was the number one cause of auto accidents in Porter County in the years before stop signs and streetlights on the corner of Central Avenue and Willowdale Road.

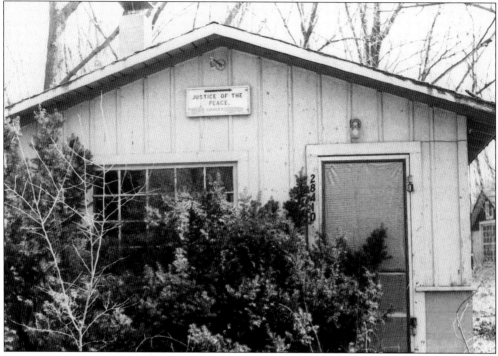

The justice of the peace was one of the most influential local offices. This was Justice Cooley's office, most suitable for conducting business—and weddings. The justice of the peace was replaced by the county clerk.

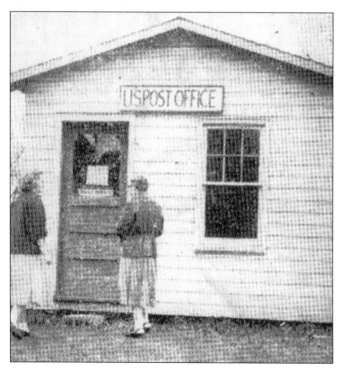

The McCool Post Office was very typical of rural postal offices. One of the last of these small facilities, the Wheeler Post Office just south of Portage, is still in use.

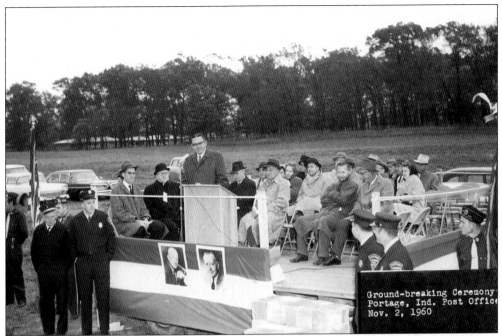

Ground-breaking Ceremony
Portage, Ind. Post Office
Nov. 2, 1960

Ground was broken for Portage's first modern post office in the 1950s at the corner of Central Avenue and Irving Street. It was replaced with a new larger post office on Willowcreek Road in 1997. This site is now a parking facility for Coach USA, the airport commuter busses.

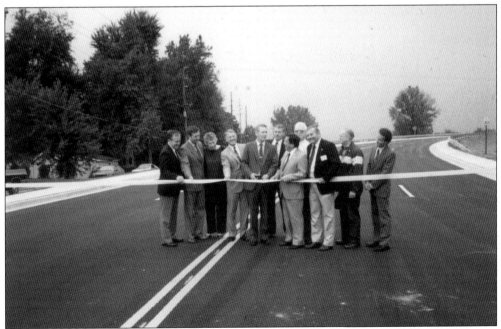

With this ribbon-cutting ceremony, the Willowcreek Overpass was officially opened. The overpass was needed to eliminate any railroad crossings. With its completion, it became the only road through Portage that goes all the way from Highway 12 in the north to 700N in the south.

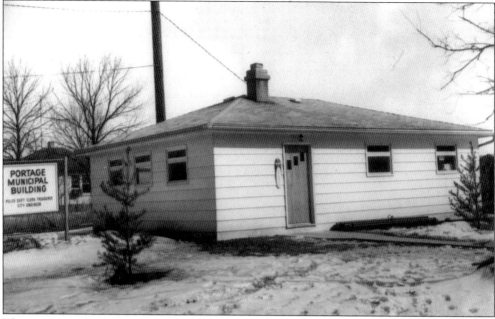

This was Portage's first municipal building, and it was used until 1967.

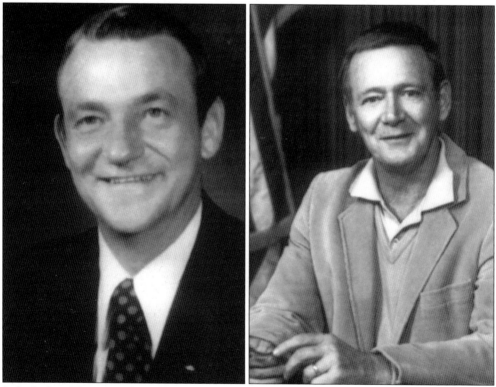

Left: Arthur Olson was elected Portage's first mayor in 1968 and served until 1972.
Right: Portage's second mayor was Robert Goin who served two consecutive terms from 1972 to 1980 and a third term from 1984 to 1988.

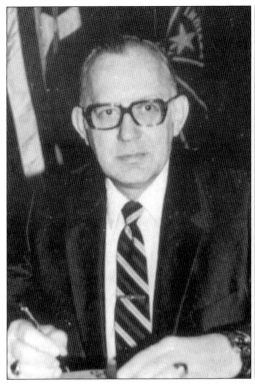

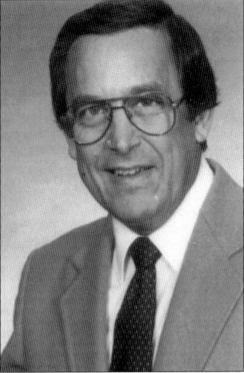

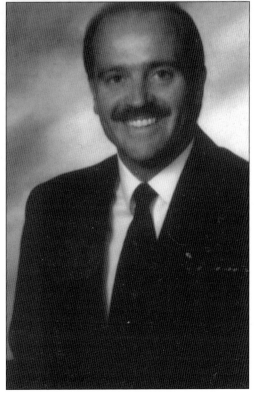

Top Left: Mayor John Williams, a retired high school teacher and later a member of the Portage Township School Board, served from 1980 to 1984.

Top Right: From 1988 to 2000, Sammie L. Maletta became the second mayor to serve three terms.

Mayor Doug Olson, who took office in 2000, is literally following in his father's footsteps.

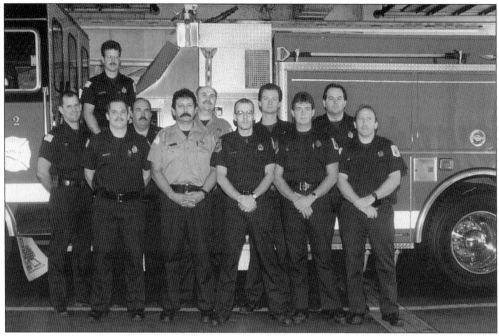

The Portage Fire Department and the Portage Police Department have the most up-to-date equipment and training available. They provide local residents with the best in safety and emergency services.

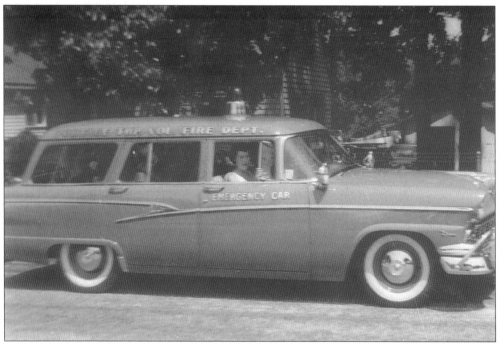

Portage Township's first Fire Department Emergency Car was this 1955 Ford station wagon, loaded with medical supplies and equipment. It is quite different from our current high-tech ambulances.

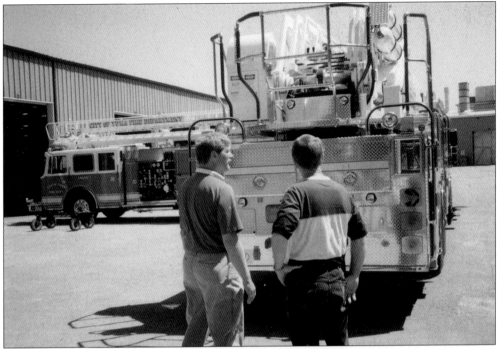

After fire destroyed the original Kelsey's Steakhouse on Highway 6 across from the high school, the fire department added this aerial ladder truck for a cost of approximately $500,00.

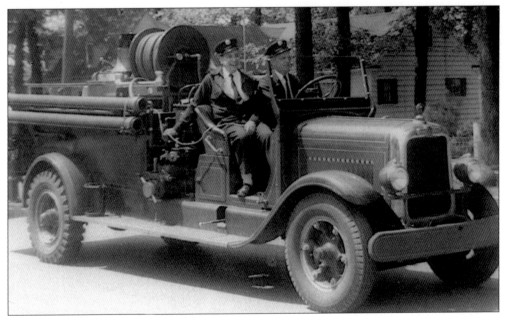

This 1920s fire engine has had several lives. When its service to Portage ended, it was then used by the South Haven Volunteer Fire Department. When it was once more relegated to retirement, Al Goin, a key member of Portage Community Historical Society, replaced missing pieces and put it back together. It is once more fully operational and will be displayed at the new museum under construction.

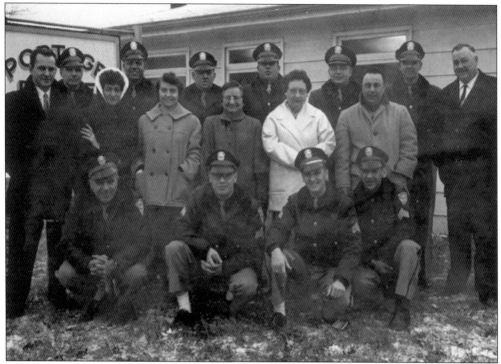

The first full-time police department was located in a frame-style ranch house. These women were the radio operators.

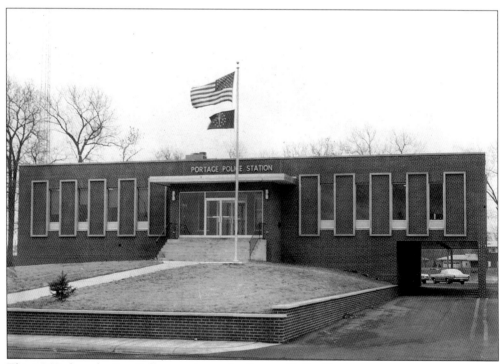

This 1968 photo by Ray Ballestero shows the Portage Police Station.

One of the police department's annual events was bicycle safety inspection conducted in the Portage Mall.

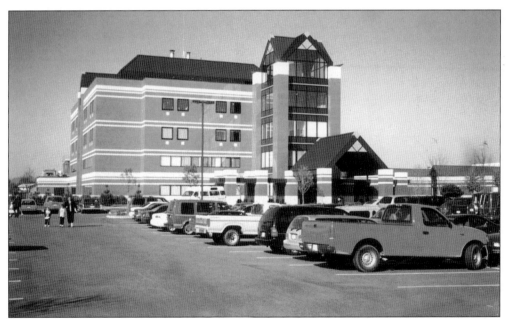

The Portage Community Hospital is both an extension and a part of Porter Memorial Hospital in Valparaiso. In addition to the hospital services, it also houses doctors' offices. Its opening has brought first-rate medical care to the residents of Portage Township and has ample room for future expansion.

When Portage became a City, one of the requirements was a sewage treatment plant. This facility is located along I-94 next to the Jellystone Campground.

The initial sewer project was completed in 1972.

The latest addition to the Portage Parks Department is Gilbert Park on Willowcreek Road, shown here under construction. Dedicated to a Portage fireman who was killed in an accident while transporting a patient to the hospital, the park also is the site of the Exchange Club's Freedom Shrine. A central gazebo has been used for evening concerts and a Kiwanis Pancake Breakfast.

A time capsule was buried in front of city hall in 1967 as part of Portage's new City status. Filled with a cache of documents and items from various residents and organizations, it was dug up in the summer of 2000 during the city's Millennium Ceremony.

ACKNOWLEDGMENTS

Thanks are given to those who furnished photographs:

The Portage Community Historical Society
The Greater Portage Chamber of Commerce
The Portage Public Library
The Portage Police Department
The Portage High School Media Center
Al Goin
Lois and Joe Mollick
Jim and Verlaine Wright
Doris Koedyker
Wanda and Norm Samuelson
Norm and Margi Hamstrom
The Portage Fire Department
Bill Messich

Futher gratitude goes out to Al Goin and Lois Mollick who put this project in motion and Jim Wright who brought this project to the finish line. Thanks go to Dennis Norman for his fortitude and mastery of the English language and to Tyler Schweitzer for his expertise on the computer.

Hats off especially to all the Historical Society members who helped and all the people who shared their great stories with us.